ENCYCLOPEDIA OF LIVING ARTISTS IN AMERICA
SIXTH EDITION

ENCYCLOPEDIA OF

IN AMERICA

EDITION 6

A CATALOG OF WORKS BY ARTISTS IN
AMERICA, COMPLETE WITH PERSONAL
PROFILES, NAMES AND ADDRESSES
OF THE ARTISTS AND THEIR AGENTS.

ART NETWORK
PRESS

Editor: Constance Franklin

Design: Laura Davis

Front Cover Details from: (top to bottom/left to right)
Ruth Hickock Schubert	Page 32
Dempsey Essick	Page 39
Niles Cruz	Page 26
Mimi Schillemans	Page 13
Richard Karwoski	Page 24
William Shih-Chieh Hung	Page 21

Back Cover Details from: (top to bottom/left to right)
Guiyermo McDonald	Page 50
Harold Parkhill	Page 45
Elizabeth Holden Slipek	Page 33
Johnny Stefann	Page 16

The Encyclopedia of Living Artists in America, Sixth Edition
serves the needs of professional members of the artworld.
Complimentary copies are available to qualified professionals
upon written request.

ArtNetwork Press, PO Box 369, Renaissance, CA 95962
916·692·1355 800·383·0677 916·692·1370 Fax

Main entry under title:
Encyclopedia of Living Artists in America
 1. Artists - Biography
 1. Art, Modern - 20th Century

ISBN: 940899-18-3
Printed in Hong Kong

C O N T E N T S

FROM THE EDITOR

Welcome to the sixth edition of the *Encyclopedia of Living Artists in America*, a celebration of contemporary art.

Once again the *Encyclopedia of Living Artists in America* offers you a chance to view the latest works of a carefully screened group of artists. In these pages you'll find painting, sculpture, mixed media, photography--art in every style and medium--created by artists who differ widely in their philosophies and backgrounds, but who share one quality: excellence. I hope you'll be excited enough by what you see to contact the artists directly and review more of their works.

Along with full-color reproductions of the artworks, the *Encyclopedia of Living Artists in America* also provides a profile of each artist, with his/her address, phone number, and agent for easy reference in alphabetical order starting on page 73. This is the portable art gallery you can tuck in your briefcase and access in seconds. It's never been so easy to add to your gallery, corporate collection, or personal collection.

In this edition we have introduced an International Section at the beginning of the book. We wish to give these outstanding artists from abroad an opportunity to expose their artworks and make connections in the United States, and what better way to do that than through the *Encyclopedia of Living Artists in America*.

I hope you'll enjoy making the acquaintance of some of today's finest artists. Happy browsing!

Constance Franklin
Editor

INTERNATIONAL ARTISTS

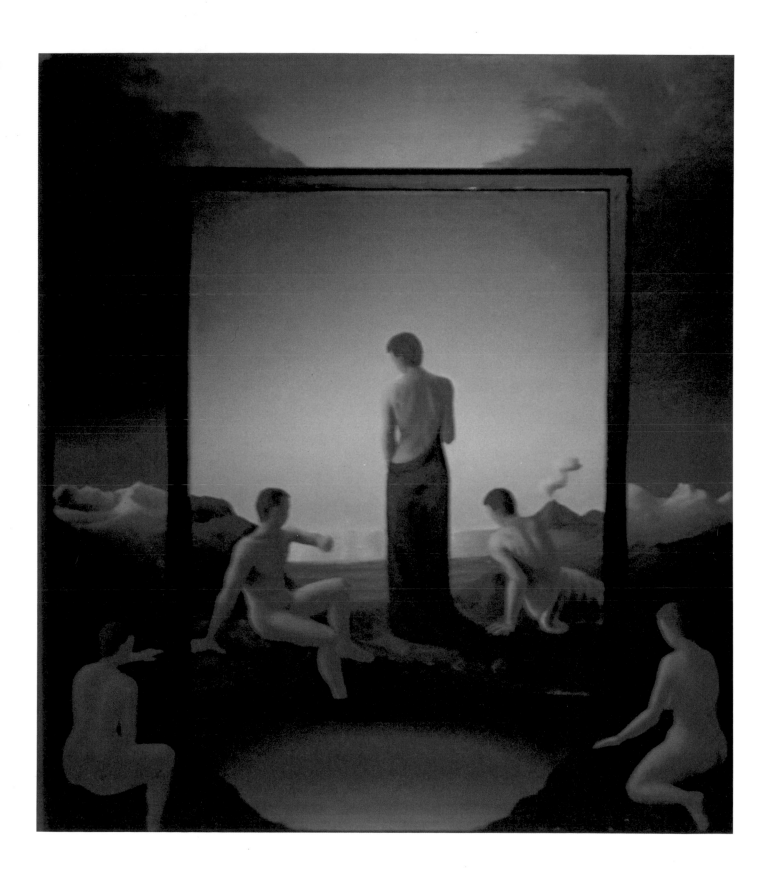

ELLING REITAN
The Sun is Breaking Through Oil, 31" x 25"
Viktor Baumanns V 19B, 7020 Trondheim,
Norway 47•07•516•538 47•07•978•416 Fax

MARLIE BURTON-ROCHE

*Entre Vagos Golpes de Azufre y Aguas Ensimismadas, Nadando en Contra de Los
Cementerios que Corren en Ciertos Rios* Oil on Belgian linen, 6½' x 10'
Ilena de Dientes y Relampagos Oil on Belgian linen, 6½' x 10'

MARLIE BURTON-ROCHE

Este Techo Esta Casa Está Destruido por el Helicoptero Oil on Belgian linen, 6½' x 10'
430 Capri Ave NW, Calgary, Alberta Canada T2L 0J8 403•282•6176

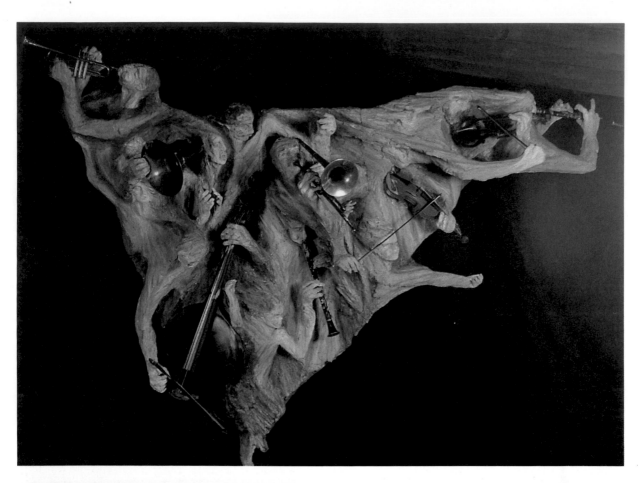

ABEL TRYBIARZ

Klezmer Music Acrylic resin/musical instruments, 144" x 58" x 109"
My Murdered Grandfather...And I Carry His Name Acrylic resin/collage, 18" x 12" x 21"
Thoughts Acrylic resin/polyester, 180" x 43" x 138"
Rosetti 556, Vicente Lopez, Buenos Aires, Argentina 1602 541•760•9882 541•775•3463

MIMI SCHILLEMANS
Harsha Oil on panel, 42" x 50"
Van Leijendberghlaan 401, 1082 GK Amsterdam,
Netherlands 31·20·642·94·64 31·20·642·99·27 Fax

EDUARDO NERY

Conjunction of the Opposites
Spray painting on golden wood panel, 36" x 48"
Av Columbano Bordalo Pinheiro, 95 - 7°, Dto,
1000 Lisboa, Portugal 726•16•68

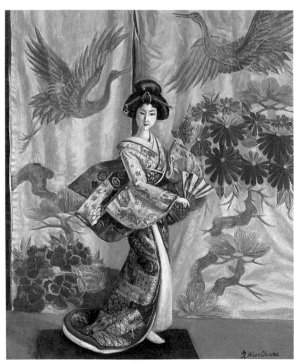

ISAO KURIHARA

Embroidery Kimono and Doll
Oil on canvas, 26" x 21"
3047-13 Fuchigashira-cho, Mitsukaido-City,
Ibaraki, Japan 303

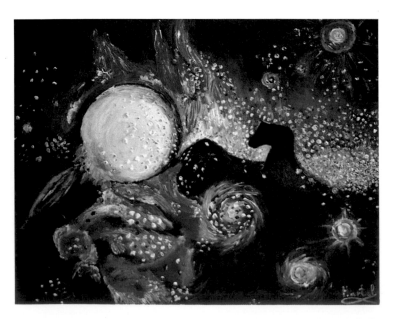

PAUL HARTAL

Horsehead Nebula Oil on canvas, 22" x 28"
PO Box 1012, St Laurent Centre for Art,
Science and Technology, Montreal, Quebec
Canada H4L 4W3 514•747•4571

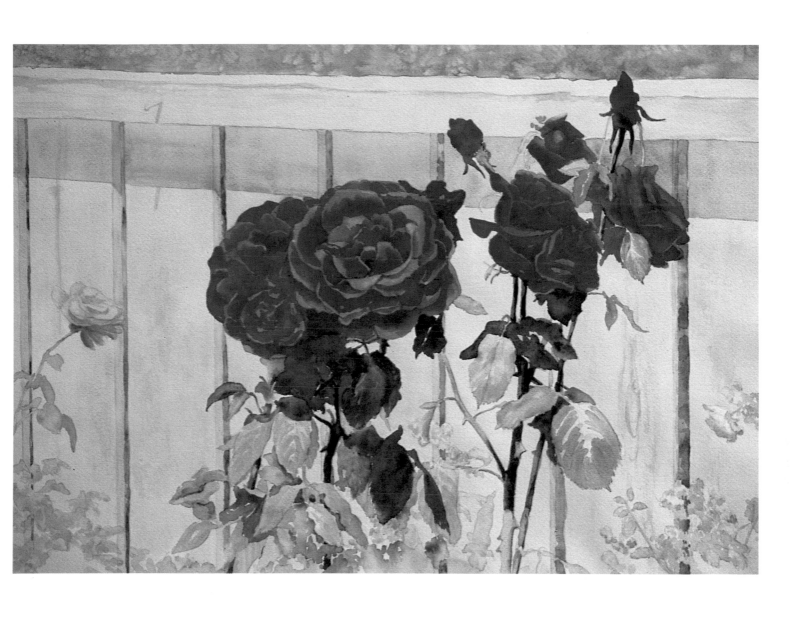

PERLA FOX

Roses Watercolor, 21 x 28½"
In America contact Jordan Fox, 4860 Van Noord Ave #4,
Sherman Oaks, CA 91423 818•990•7762

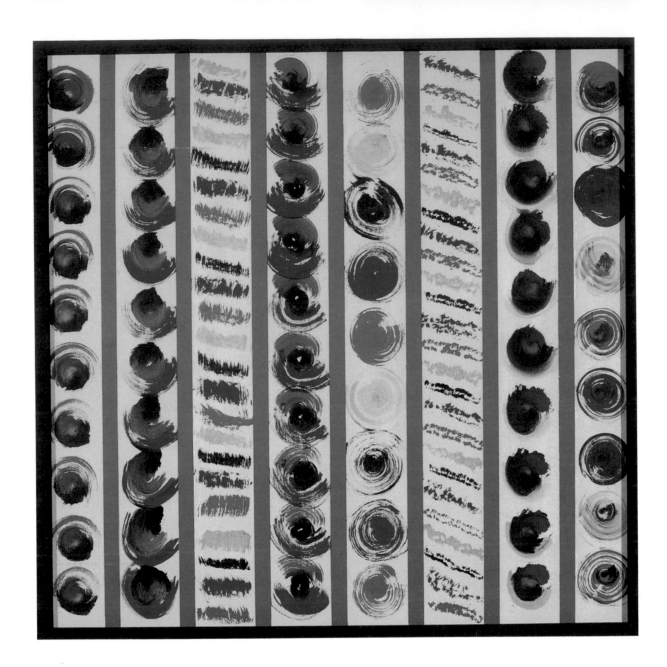

JOHNNY STEFANN

Contrasto Acrylic on wood, 40" x 40"
Movimento Acrylic on wood, 40" x 40"
In America contact PO Box 500, Oregon House,
CA 95962-0500 916•692•1356 916•692•1370 Fax

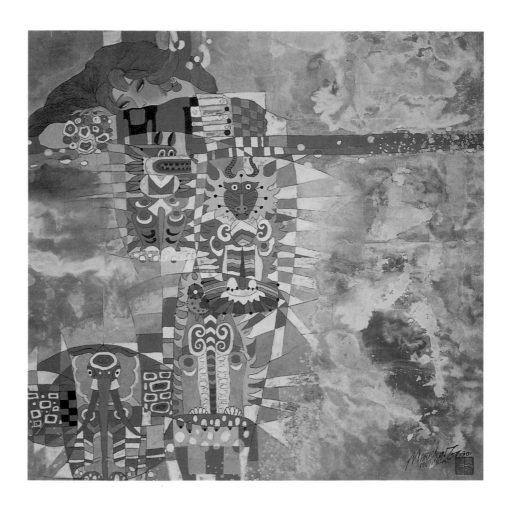

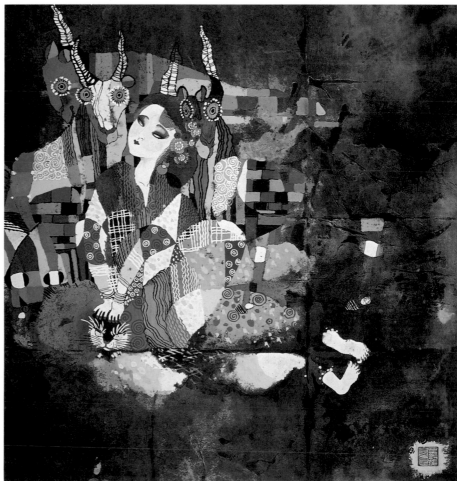

NI BING
(MARK LOONG)
Inside a Dream Chinese watercolor
on rice paper, 28" x 25½"
Goat Breeding Chinese watercolor
on rice paper, 22½" x 23½"
Represented by T & T Art Studio,
888 Brannan St, Suite 3030,
San Francisco, CA 94103
415•626•1180 415•626•0881 Fax

AMERICAN ARTISTS

BRIAN FLYNN
44 Margarets Mixed media on board, 24" x 36"
PO Box 500, Oregon House, CA 95962-0500
916•692•1356 916•692•1370 Fax

19

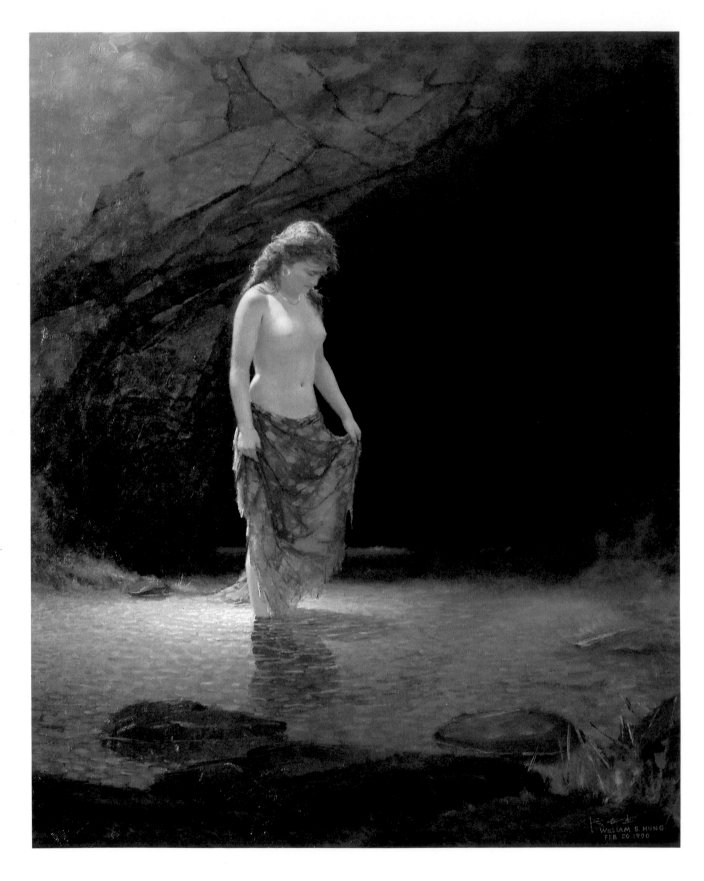

WILLIAM SHIH - CHIEH HUNG

Red Apron Oil on canvas, 38" x 30"

WILLIAM SHIH-CHIEH HUNG

Chinese Lady (A Portrait of My Wife Susie Hsueh-Ping)
Oil on canvas, 36" x 30"
PO Box 20133, El Sobrante, CA 94820

LOIS VENARCHICK
Argument's Reign Mixed media, 12" x 14"
660 Beckett Point Rd, Port Townsend, WA 98368
206•385•3998

RODNEY CHANG
Hot Bed Cibachrome print, 16" x 20"
Represented by Art Resource Group,
Eugene M Siegel, 1179 Kahili St,
Kailua, HI 96734
808•262•1878 808•262•2152 Fax

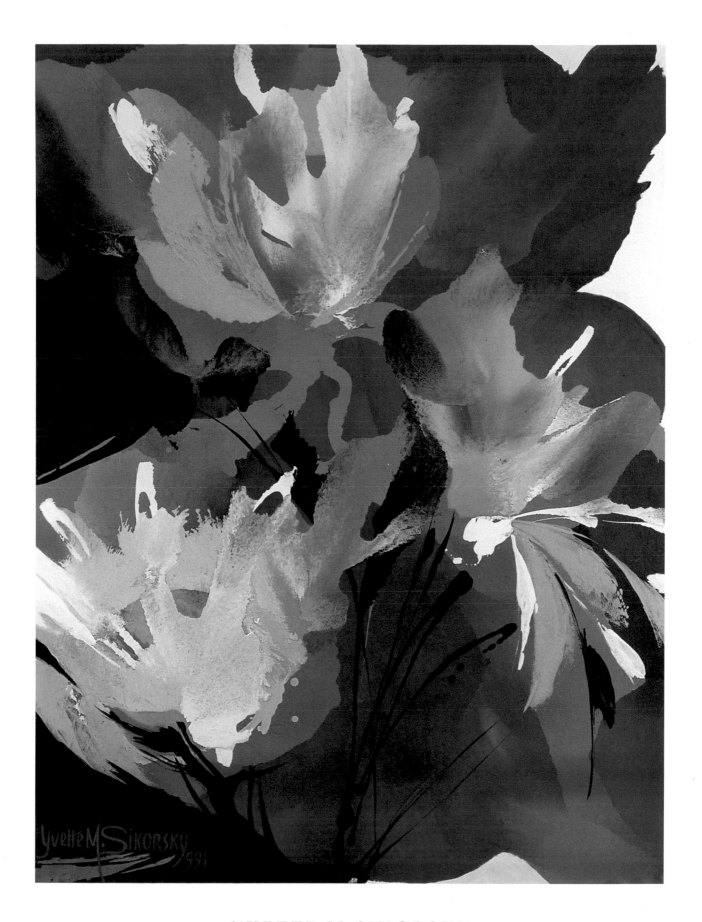

YVETTE M SIKORSKY

Floribunda Acrylic, 36" x 48"

PO Box 146, Lake Mohegan, NY 10547 914•737•5167

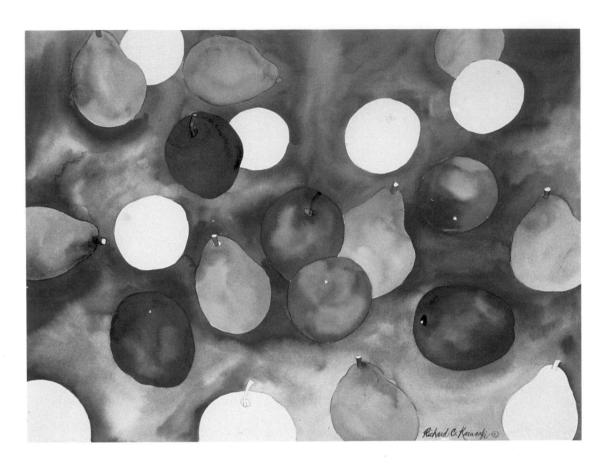

RICHARD KARWOSKI

Mixed Fruit on Blue Watercolor, 22" x 30"
Nasturtiums in Monterey Watercolor, 22" x 30"
28 E 4th St, NY NY 10003 212•254•1618

24

MICHAEL PETER ROSS
Kiteman 709 Photography, 24" x 36"
10667 Porto Ct, San Diego, CA 92124 619·279·3289

NILES CRUZ

Night Sparks
Acrylic on canvas, 48" x 64"
The Ordinary Life
Acrylic on canvas, 48" x 64"
14 Jackson Pl, Brooklyn, NY 11215
718•499•1457

W T ELKINS
Old Friends Oil, 20" x 24"
PO Box 4447, Anaheim,
CA 92803 714•635•1995

MARIA DELIA BERNATE KANTER

The Condor of the Andes Acrylic on canvas, 48" x 36"
6155 La Gorce Dr, Miami Beach, FL 33140 305•865•9406

SILJA LAHTINEN-TALIKKA

Atlanta Spring Oil on canvas, 22" x 36"
Tornado Season Acrylic on canvas, 72" x 130"
5220 Sunset Tr, Marietta, GA 30068 404•992•8380

ALVIN C HOLLINGSWORTH

City in Gold and Black (Lincoln Center Series) Oil and acrylic collage, 28" x 36"

ALVIN C HOLLINGSWORTH

He Lives (Visionary Series) Oil and acrylic, 46" x 56"
614 W 147th St, NY NY 10031

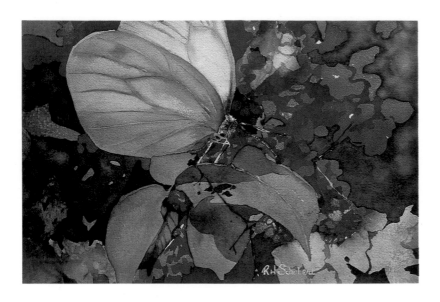

RUTH HICKOK SCHUBERT

Christmas Anniversary
Watercolor (transparent), 22½" x 30"
2462 Senate Way, Medford, OR 97504
503•772•0136

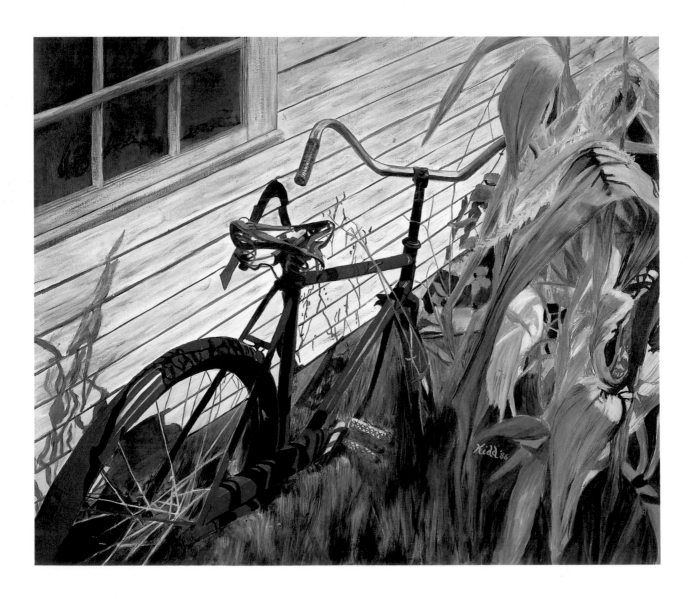

NANCY KIDD

Grandpa's Bike Acrylic, 35" x 41"
930 Rockefeller Dr #16A, Sunnyvale, CA 94087 408•773•0971

ELIZABETH HOLDEN SLIPEK

High Noon Oil, 30" x 36"

3218 Seminary Ave, Richmond, VA 23227 804•355•0097

33

JUSTIN H SUNWARD

Transmutations 32 Oil on canvas, 41" x 41"
6054 N Hermitage, Chicago, IL 60660
312•508•5046

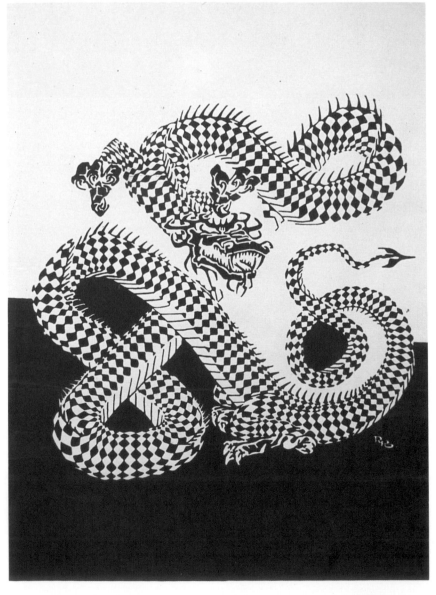

ROBERT F KAUFFMANN

Division of Plane with Dragon Serigraph, 18" x 24"
2401 Arden Rd, Cinnaminson, NJ 08077
609•829•7725

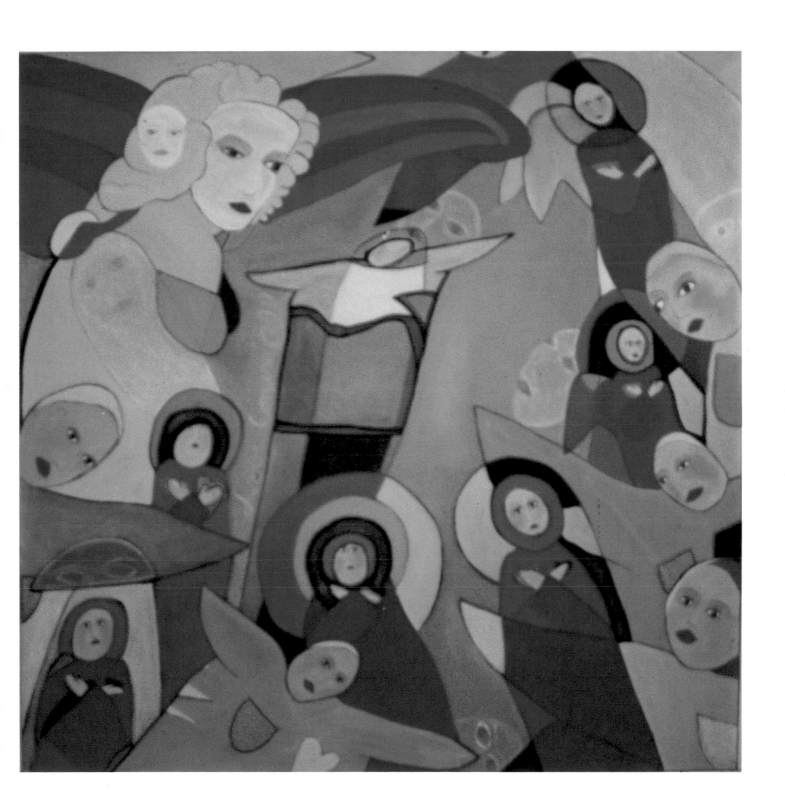

STEPHEN JOHNSON
The We Love You Painting: Jesus, Ginger and Mozart
Acrylic on canvas, 36" x 36"

580 Auburn Rd NE, Salem, OR 97301 503·581·3397

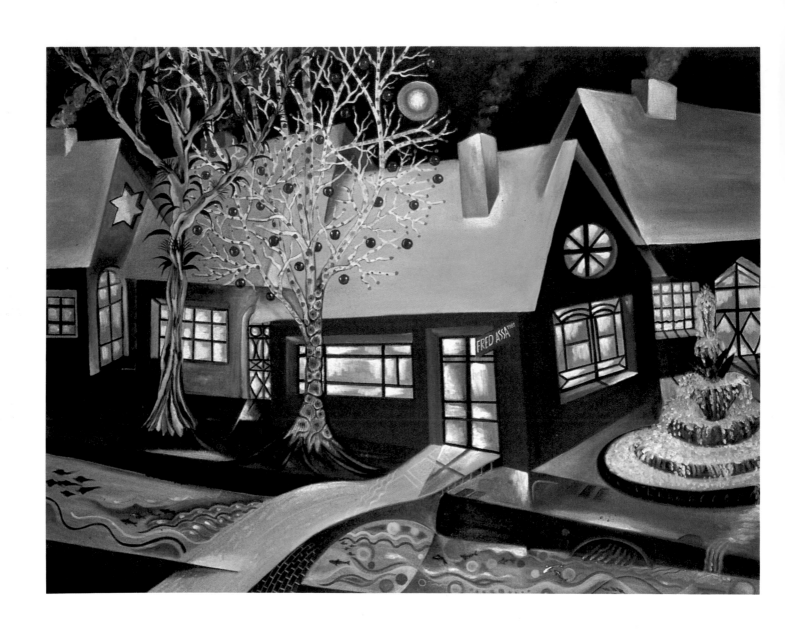

FRED ASSA

Metaphor of Light Dream Oil, 30" x 40"

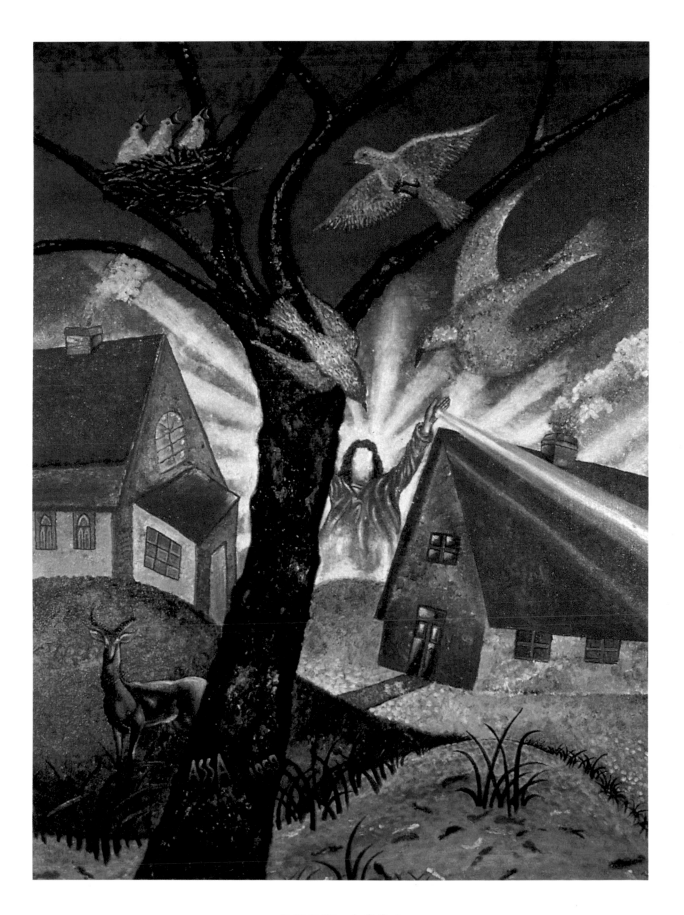

FRED ASSA

Dawn of Spirituality Oil, 40" x 30"
241 Palisade Ave, Jersey City,
NJ 07306 201•963•8428

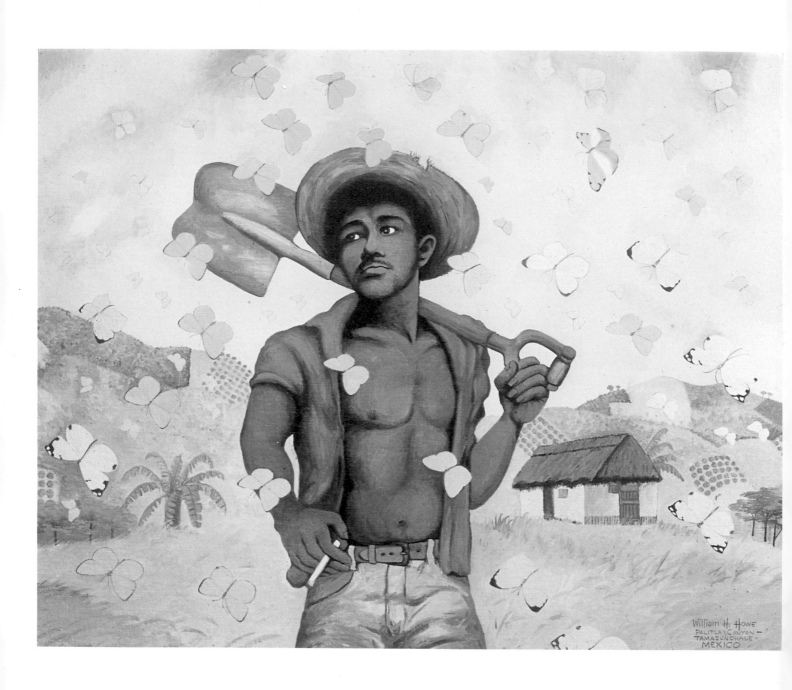

WILLIAM HOWE

Mexican Mosaic Acrylic on canvas, 24" x 30"
822 E Eleventh St, Ottawa, KS 66067 913•242•4148

DEMPSEY ESSICK

Springtime at Irena's Watercolor, 22" x 26"

Rt 18 Box 2518, Lexington, NC 27292 704•249•9857

R M SUSSEX
St Michael's by the Sea Oil, 18" x 24"
2005 S Fairway Dr, Pocatello, ID 83201 208•237•3396

GRACE MERJANIAN
Promise of Spring Watercolor with gouache, 21" x 30"
18701 Deodar St, Fountain Valley, CA 92708 714•968•5983

JAN COOPER
Camelot Acrylic, 22" x 28"
Box 18, North Highlands,
CA 95660 916•726•0911

41

ATHENA LACIOS

Greek Landscape Oil, 20" x 23"
103 Roberts Rd, Englewood, NJ
07632 201·568·3355

DAVID LEON HOLT

Figures within the Plane Soft pastel/charcoal, 14" x 17"
1245A Rodriguez St. Santa Cruz. CA 95062
408·475·1815

GILDA PORCORO

The Barn Oil
5-18 Canger Pl, Fairlawn, NJ 07410
212·535·4181

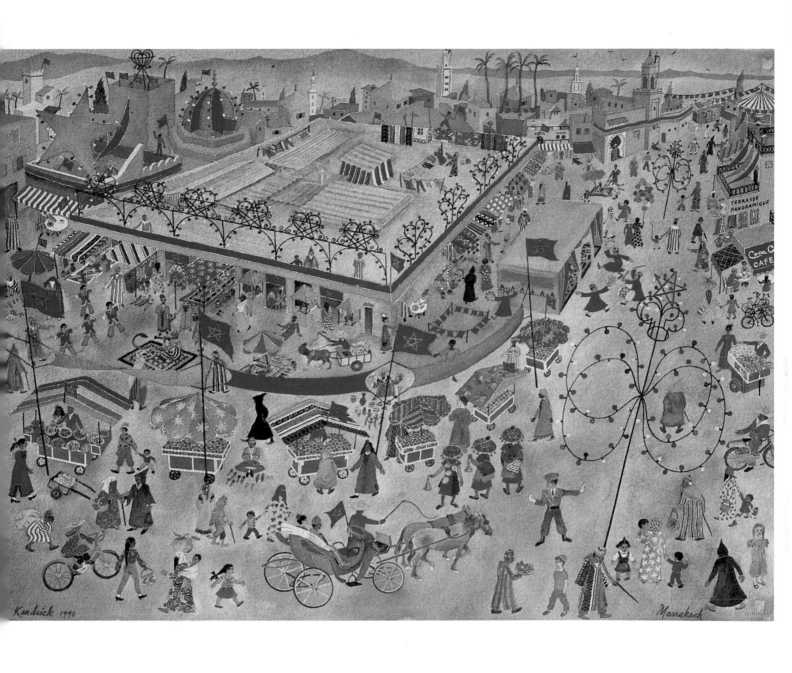

WILLIAM KENDRICK

Marrakech Watercolor, 22" x 30"

1410 Cole Blvd, Glen Allen, VA 23060 804•266•6269

43

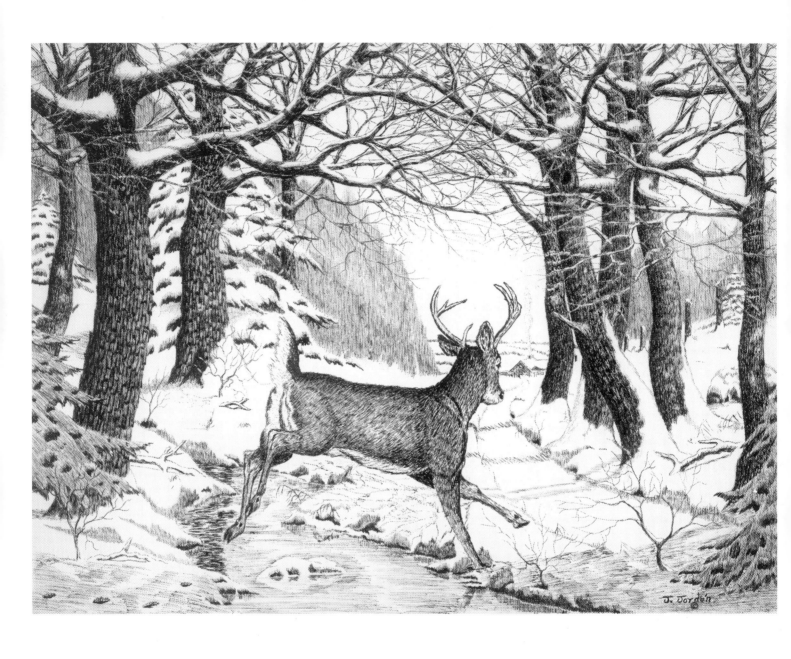

JOHNNIE JORDAN

After Hunting Season Pen and ink on illustration board, 28¾" x 18¾"
6400 N 11th St, Philadelphia, PA 19126-3730 215•424•0331 215•224•6895 Fax

HAROLD PARKHILL

Our Heritage Oil, 28" x 30"

PO Box 85, Coshocton, OH 43812 614•623•8852

MICAH SANGER

Saddle Oil on canvas, 28" x 34"
The Buttes - Williams Road II Acrylic on canvas, 30" x 40"

46

MICAH SANGER
Mystical House II Watercolor and pastel on paper, 18" x 14"
PO Box 626, Oregon House, CA 95962-0626 916•692•1880 916•692•1370 Fax

MICHAEL RASMUSSEN
The Archer Casein on canvas, 11" x 14"
1122 Portland Pl #208, Boulder, CO 80304
303•449•7924

GARY BRINLEY
O.D.E. Hayter
Engraving with soft ground etching, 11¼" x 11½""
2208 Bryan Dr, High Ridge, MO 63049 314•677•6083

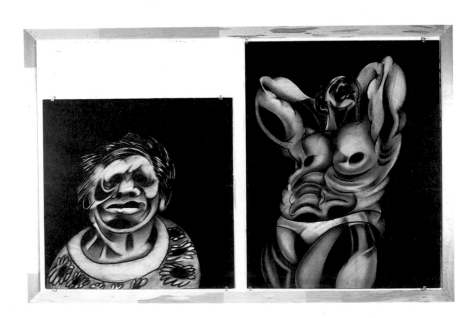

PETER DEROZZA
Madonna and Child Charcoal, 77⅞" x 50¼"
540 Blaisdell Dr, Claremont, CA 91711 714•624•2271

R RANDALL IACCARINO

La Mantra de Itabo (The Blanket of Itabo)
Watercolor, 48" x 48"
115 McClellan Blvd, Davenport, IA 52803 319•359•5522

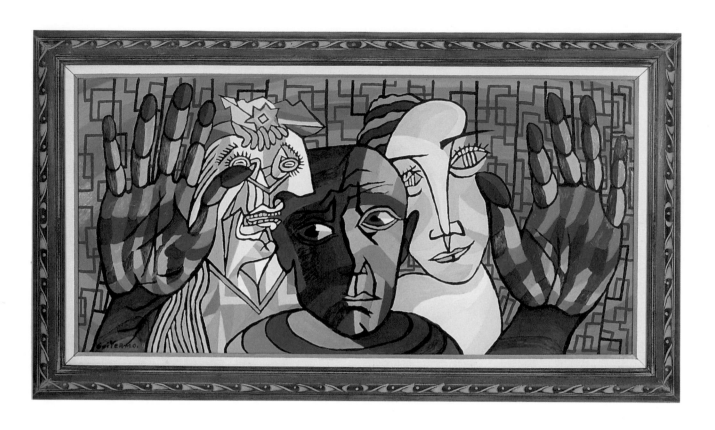

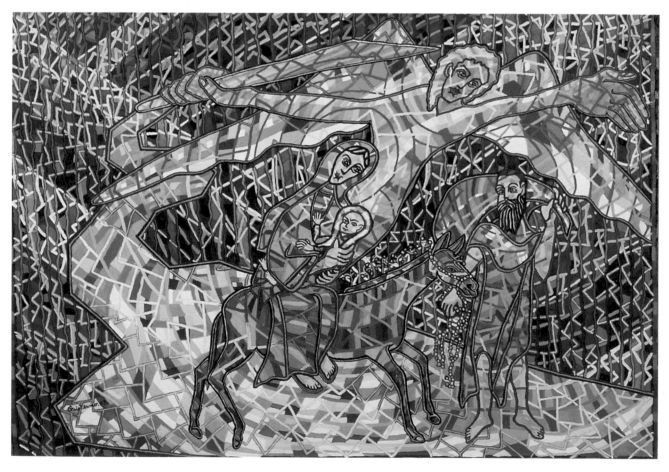

GUIYERMO MCDONALD

Tribute to Picasso Oil on masonite, 24" x 48"
Flight into Egypt Oil on canvas, 37" x 53"

50

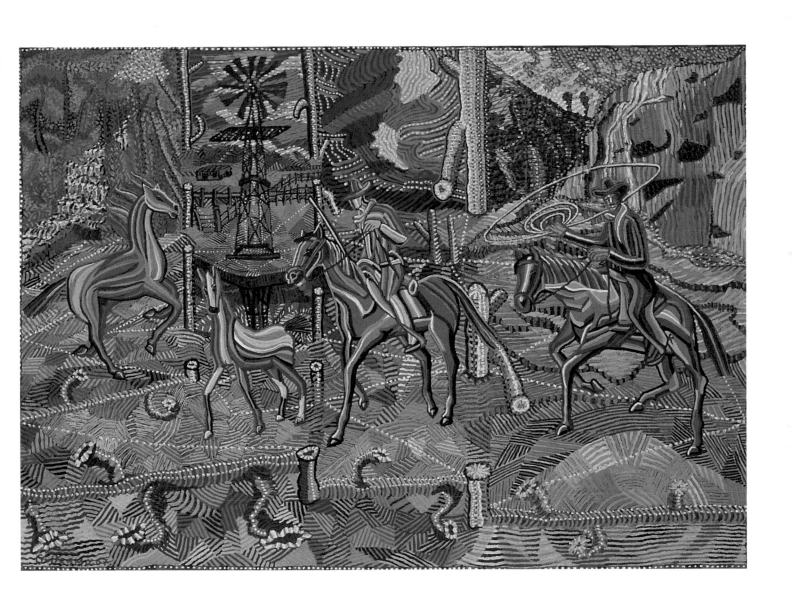

GUIYERMO MCDONALD

The Seven Colored Horse Oil on canvas, 37" x 53"
60 Matisse Rd, Route 5 Box 5464,
Albuquerque, NM 87123 505•293•2276

EUSTACHY MICHAJLOW

Haziness Oil, 16" x 20"
Steppecossock Oil, 18" x 24"
341 Rio Grande Dr, Edgewater, FL 32141 904•423•4683

52

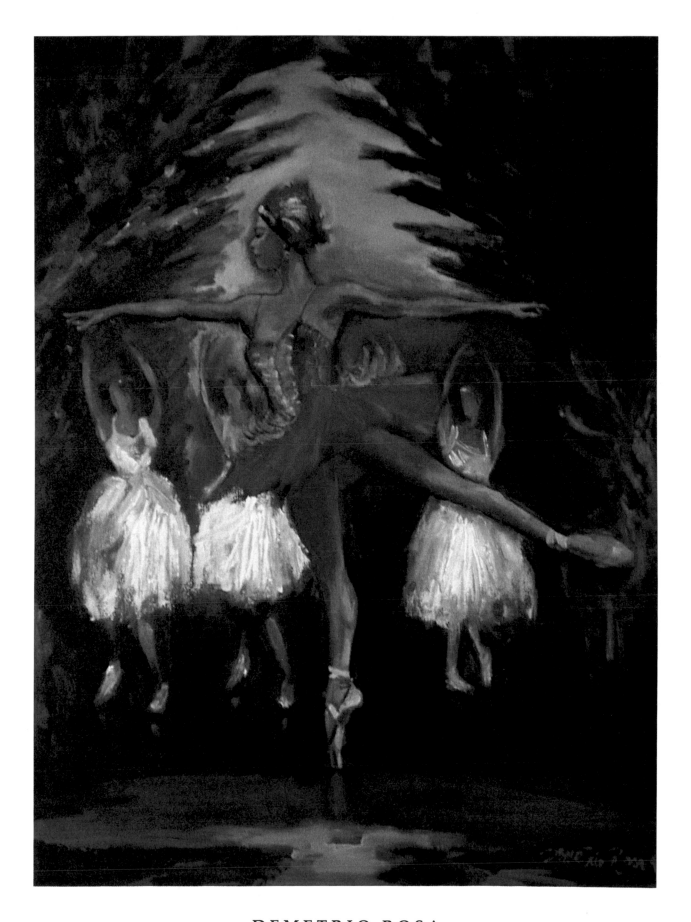

DEMETRIO ROSA
The Firebird Oil, 22" x 28"
87-G Howard Dr, Bergenfield, NJ 07621
201•385•7055 201•831•1720

IVO DAVID

The Filthy Harpies, Dante's Inferno XIII
Oil on canvas, 22" x 30"
2027 High St, Union, NJ 07083 908•964•5660

HOPE MARIE MAKI
Mother and Child Mermaid Oil, 22" x 28"
3985 Langley Ave, Pensacola, FL 32504 904•478•4673

RON JONES
Billy Platinum-Palladium, 18" x 12"
Gullfriend Platinum-Palladium, 18" x 12"
Maine Fog Platinum-Palladium, 17" x 14"
2406 Birch Dr, Silver Spring, MD 20910
301·587·2210 301·588·2708

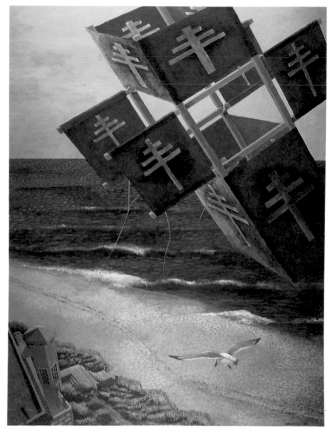

JOHN OSHYPKO
Paean to Coke
Alkyd on canvas, 36" x 36"
Kite Over Dune Point
Acrylic on canvas, 48" x 36"
13 Fifth Ave, PO Box 311
Brentwood, NY 11717-0311
516•273•6023

ALAN PLAVEC

Kinetic Form Watercolor, 36" x 28"
608 Krenz Ave, Cary, IL 60013
708•639•2889

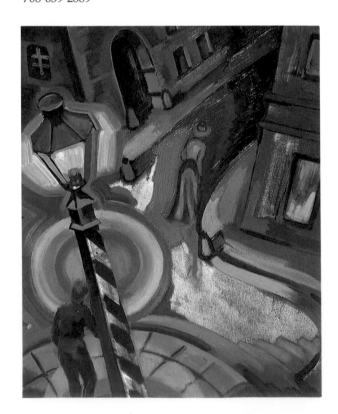

LUDMILA GAYVORONSKY

It Is Over Oil on canvas, 20" x 24"
1690 Union St #2C, Brooklyn, NY 11213
718•756•3453

PETER CHRISLER
Garden Facade of Palace
Ceramic with porcelain finish, 12½" x 15"
1745 Franklin St #204, San Francisco,
CA 94109 415•673•7754

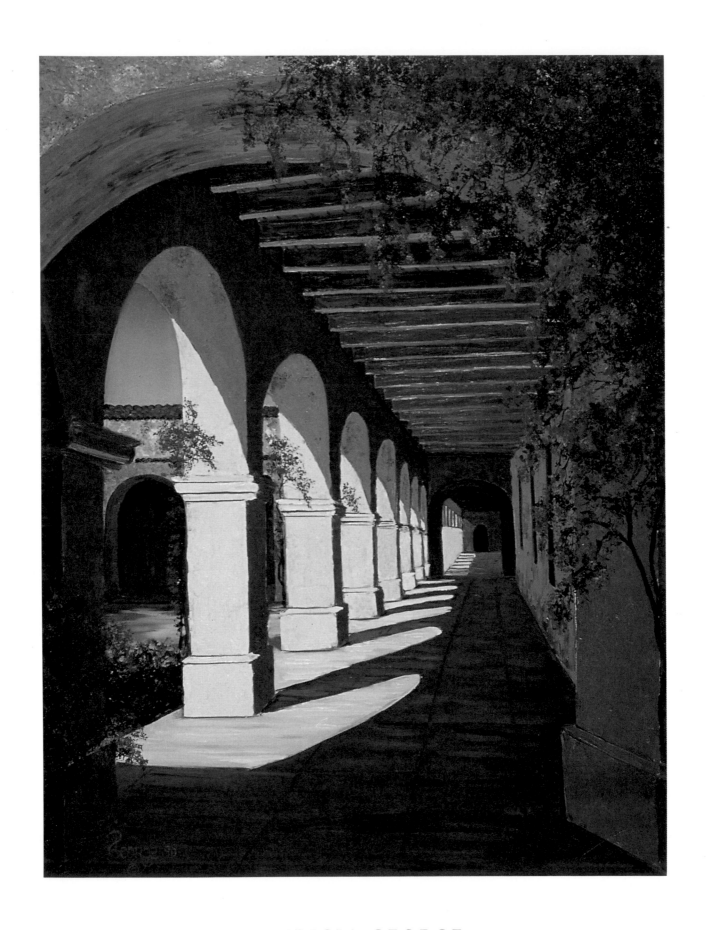

PATRICIA GEORGE

Arch Shadows Oil on canvas with knife, 30" x 40"

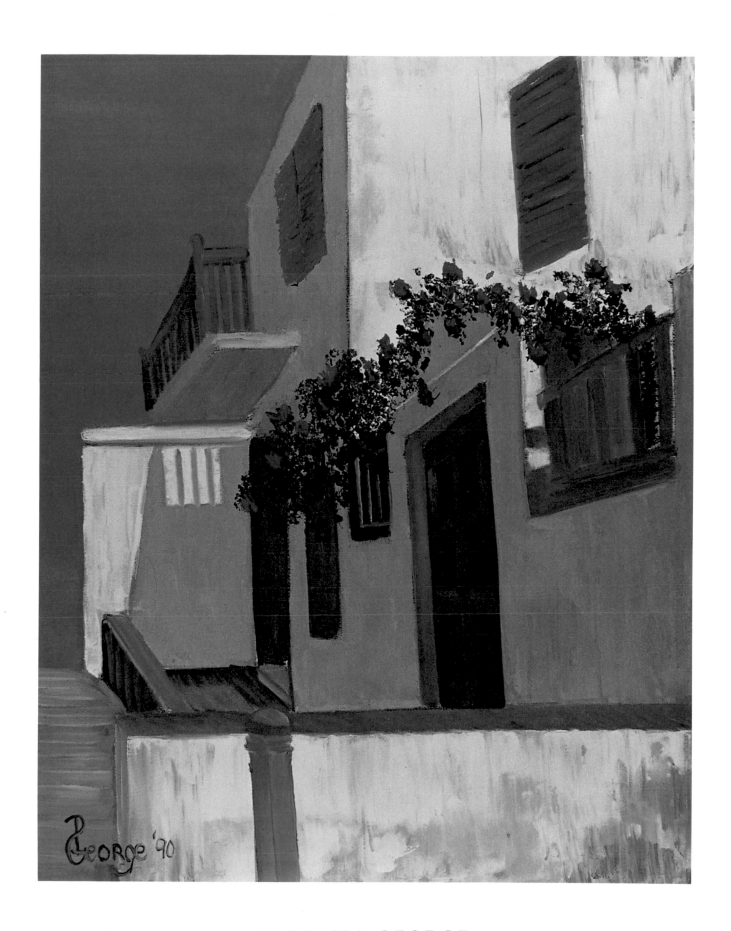

PATRICIA GEORGE

Santorini Shadows Oil on canvas with knife, 20" x 24"

Suite 221, 4141 Ball Rd, Cypress, CA 90630 714•826•7945

DOROTHY ROATZ MYERS

Found Safe Oil, 16" x 24"
Box 204, FDR Station, NY, NY 10150-0204
212•838•0932

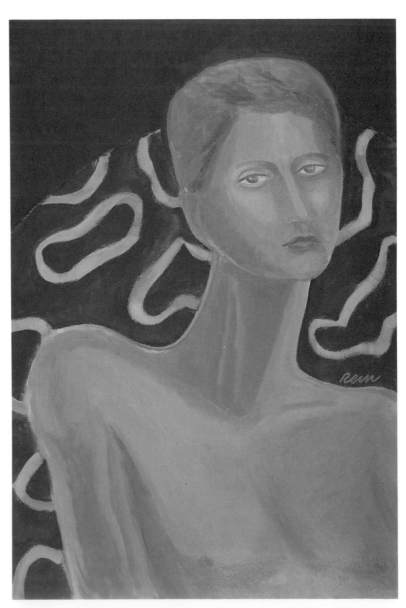

ROYCE MARIN REIN

The Red Room Acrylic on canvas, 36" x 24"
2548 Clinton Ave S, Minneapolis, MN 55404
612•874•9377

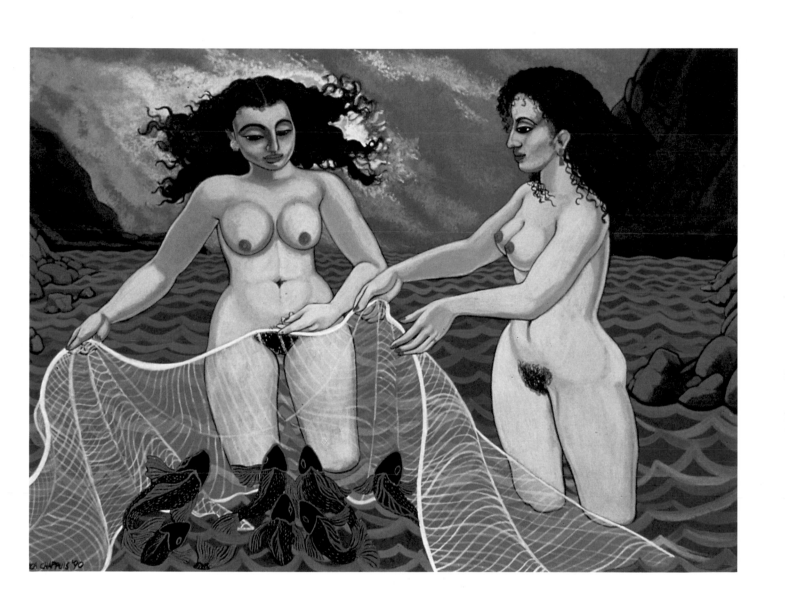

ERICA CHAPPUIS

Little Fishes Acrylic on museum board
with enamel paint, 7" x 9"
1251 Beaconsfield, Grosse Pointe Park,
MI 48230 313•822•3647

63

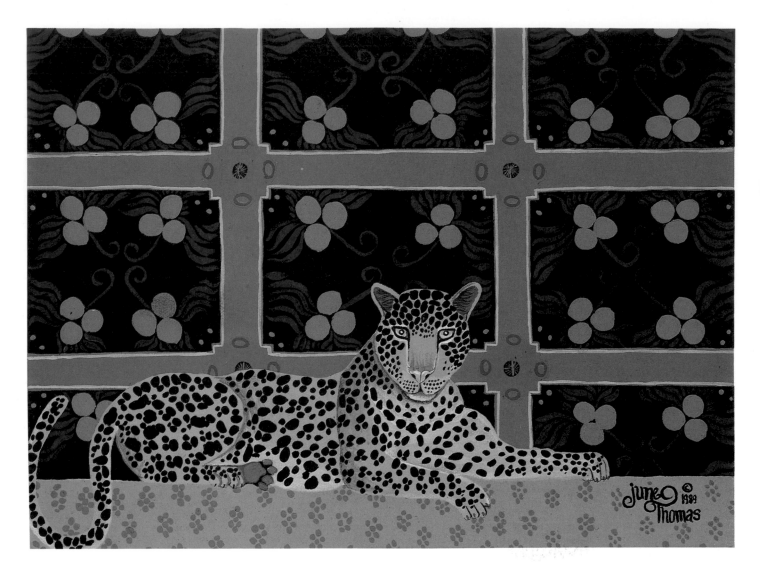

JUNE THOMAS
Leopard on Beige Carpet Acrylic, 9" x 12"
450 Citrus Ave, Imperial Beach,
CA 91932 619•423•1480

WINSTON HOUGH
Matisse Park Acrylic, 47" x 33½"
937 Echo Lane, Glenview, IL 60025
708•729•0915

VAL BERTOIA

B-354 Welded bronze, 11" x 4" x 6" with brass base
644 Main St, PO Box 383, Bally, PA 19503 215•845•7096

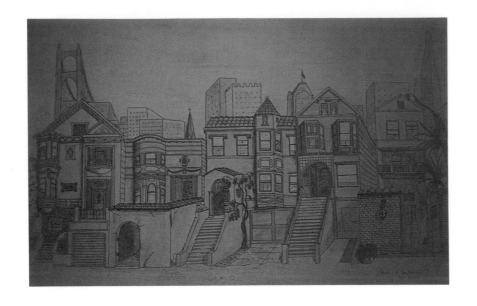

INGE BEHRENS
Victorian Homes of San Francisco
Pen and ink hand colored with pencil, 20" x 30"
2824 Velvet Way, Walnut Creek, CA 94596
415•937•7557

ROLLA · RICH
Columbus Day
Tempera and acrylic, 22" x 30"
PO Box 7, Imperial, CA 92251
619•352•2319

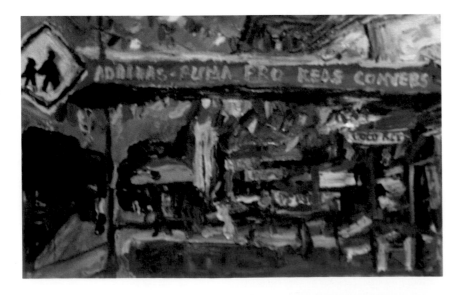

PHILIP SHERROD
Walking-sign/Adidas/Pro-Keds on Upper Broadway
Oil on canvas, 21¾" x 34¾"
41 W 24th St, 4th Floor, NY NY 10010
212•989•3174

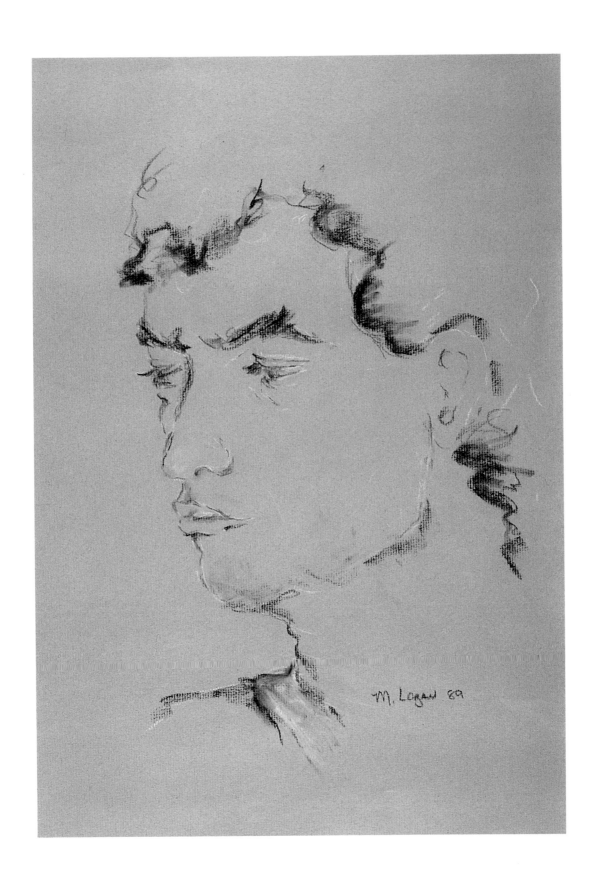

MARY LOGAN
Mike Pastel, 18" x 24"
PO Box 4364, Bellingham,
WA 98227 206•671•2253

CAROL TUDOR BEACH

Sulky Table Acrylic and gold-leaf on Victorian table, 24" x 38"
2217 40th St NW #3, Washington, DC 20007 202•337•5416

MABEL MARTIN DAVIDSON

My Judy Acrylic, 14" x 11"
Rt 2 Box 431, Mt Vernon, KY 40456 606•965•3123

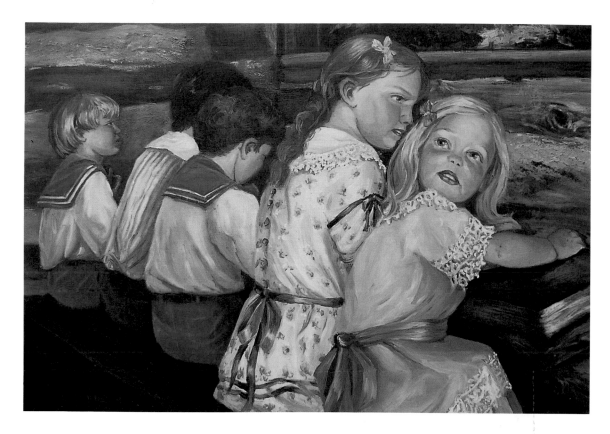

BIRDELL ELIASON

Early American Classroom Oil on masonite, 16" x 20"
Grandma's Daisies Oil on canvas, 16" x 20"
12 N Owen St, Mt Prospect, IL 60056 708•259•6166

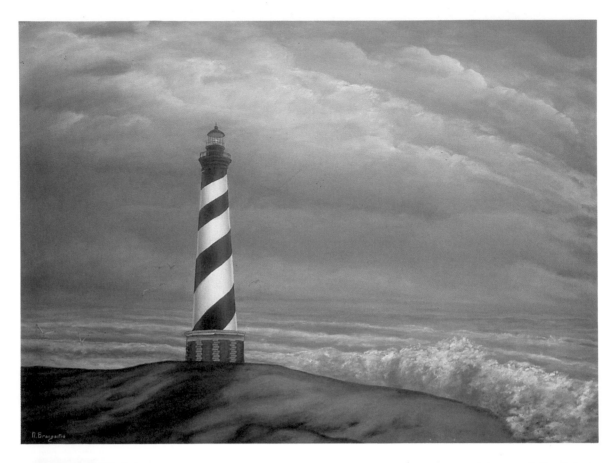

N BRANGAITIS

Cape Hatteras Light House Oil on canvas, 30" x 40"
Sea Wolf Oil on canvas, 18" x 24"

70

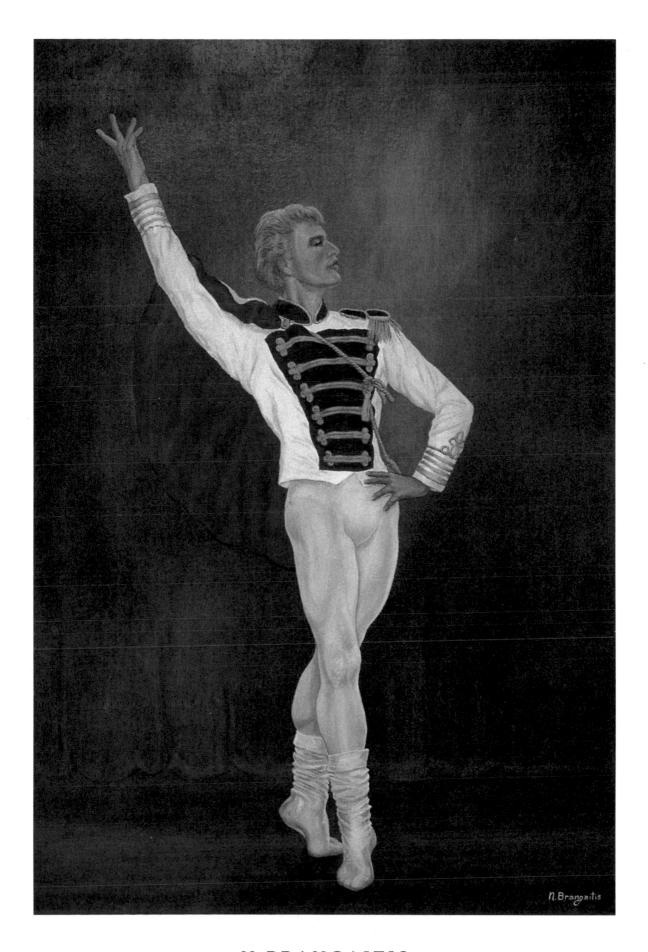

N BRANGAITIS

Curtain Call Oil on canvas, 24" x 36"
Rt 1 Box 5, Brasstown, NC 28902-9704

ARTISTS' PROFILES

FRED ASSA

36 *Metaphor of Light Dream*
 Oil, 30" x 40". Artist's collection.

37 *Dawn of Spirituality*
 Oil, 40" x 30". Artist's collection.

Fred Assa's work has traditionally been characterized by designs that combine line, color, and form to reach a state of intricate perfection in a cosmos where the harmony of each delicate detail is essential. Assa's work has been published by UNICEF and Easter Seals, collected by Columbia University, The United Nations, the Israel Museum and other important collectors. His most recent work explores contemporary American scenes utilizing a bold, dynamic approach from the perspective of his own unique world view - impressionist/fantasy style. Interest in his work for sales and exhibit has been rapidly expanding throughout the world.

241 Palisade Ave, Jersey City, NJ 07306 201·963·8428

CAROL TUDOR BEACH

68 *Sulky Table*
 Acrylic and gold-leaf on Victorian table, 24" x 38".

Carol Tudor Beach is a mural painter and painter of furniture. Her subject matter includes flowers, horses, landscapes and abstracts. She works predominantly in acrylic and watercolor, sometimes in oil. Beach is also proficient in gold-leaf, and architectural rending in watercolor and graphite. She is published in *Architecture and Urbanism, Architectural Record, Vail Magazine, L'Ambiente Cucina* and *Interior Design*. She received her BFA from the Rhode Island School of Design in 1981.

2217 40th St NW #3, Washington, DC 20007 202·337·5416

INGE BEHRENS

66 *Victorian Homes of San Francisco*
 Pen and ink hand colored with pencil, 20" x 30".
 Artist's collection.

Inge Behrens studied fashion design and pattern-making in Germany and the US. She has enjoyed drawing and painting for as long as she can remember. For financial reasons, she had to wait years before beginning serious, full-time painting. Her preferred subjects include victorian houses, ghost towns, old buildings and European castles. In 1989 Behrens published a pictorial history of Walnut Creek, commemorating its 75th anniversary, and received recognition from Mayor Evelin Munn for this achievement.

2824 Velvet Way, Walnut Creek, CA 94596 415·937·7557

VAL BERTOIA

65 *B-354*
 Welded bronze, 11" x 4" x 6" with brass base.
 Artist's collection.

In an interview Val Bertoia was asked, "Why do you make sculptures of metal?" He replied, "From the universe, I receive metal-energy. My welded-bronze 'bushy' sculpture can only be made of metal, because its many feather-like branches must have resilience, permanence, beauty, color, texture, and sometimes pleasant sounds. All of these qualities represent me. And I am more than these; I think and grow, and because of this, I must make many sculptural forms to continuously represent me, one for each important moment of my life on Earth."

644 Main St, PO Box 383, Bally, PA 19503 215·845·7096

NI BING (MARK LOONG)

17 *Inside a Dream*
 Chinese watercolor on rice paper, 28" x 25½".
 Private collection.

17 *Goat Breeding*
 Chinese watercolor on rice paper, 22½" x 23½".
 Private collection.

Ni Bing (Mark Loong) is an accomplished artist born in 1967 in Wuhan City, Hubei Province, China. He has received many honors and prizes and participated in competitions and exhibits since he was 10 years old. He spent two years, from 1985 to 1987, completing a 110 foot painting entitled "Celestial Birthday Celebration." This painting shows over two thousand figures and a hundred birds and beasts living among rivers and lakes. It is divided into six sections and is currently in the collection of the Chinese National Museum in Beijing. His artworks were recently accepted by a Hong Kong Auction House and successfully sold.

Represented by T & I Art Studio, 888 Brannan St, Suite 3030, San Francisco, CA 94103 415·626·1180 415·626·0881 Fax

N BRANGAITIS

70 *Cape Hatteras Light House*
 Oil on canvas, 30" x 40". Artist's collection.

70 *Sea Wolf*
 Oil on canvas, 18" x 24". Private collection.

71 *Curtain Call*
 Oil on canvas, 24" x 36". Artist's collection.

From the Maine Coast to Cape Hatteras, North Carolina, the power and the glory of the sea captivate this artist. Since

migrating from upstate New York to North Carolina, she has added animals, especially horses, to her subject matter. Brangaitis oil paintings hang in corporate and private collections in the United States and abroad.

Rt 1 Box 5, Brasstown, NC 28902-9704

GARY BRINLEY

48 *O.D.E. Hayter*
 Engraving with softground etching, 11¼" x 11½".

Education: Webster University, MO; BA 1989
 Jefferson College, MO; AA 1986
Exhibits: Cecille R Humb. Received an award for a sugar aquatint etching.

2208 Bryan Dr, High Ridge, MO 63049 314·677·6083

MARLIE BURTON-ROCHE

10 *Entre Vagos Golpes de Azufre y Aguas
 Ensimismadas, Nadando en Contra de Los
 Cementerios que Corren en Ciertos Rios*
 Oil on Belgian linen, 6½' x 10'. Artist's collection.

10 *Ilena de Dientes y Relampagos*
 Oil on Belgian linen, 6½' x 10'. Artist's collection.

11 *Este Techo Esta Casa Está Destruido por el
 Helicoptero*
 Oil on Belgian linen, 6½' x 10'. Artist's collection.

Marlie Burton-Roche is a Canadian artist who works in solidarity with the people of El Salvador. Her recent artwork, a series of paintings and sculptures entitled *If You Don't Want To Be the Horses' Hoofprints, You've Got to Be the Hooves*, is resultant from her experiences in Central America and reflects her abhorrence of the daily reality the people of El Salvador must face. "My ambition is to create art that can evoke a response, either emotive or conceptual, that will stimulate thought as well as action and somehow address this travesty of justice in El Salvador." Her works are massive in scale, using a highly polished glazing technique and intense colours. "To work with and manipulate colour and light is, to me, one of the greatest pleasures." The main justification for her current work is political. "We live in a whole world of active and interactive relationships that can and should be expressed artistically. It is impossible to know about the harassment, torture, and murder of Salvadoreans and to know that despite the repression, the people of El Salvador are working to establish their ideals of social justice and self-reliance, and not have it effect one's art." Her paintings and sculptures have been exhibited across Canada. She has artworks in public and private collections in Canada, Israel, Britain and India.

430 Capri Ave NW, Calgary, Alberta Canada T2L 0J8
403·282·6176

RODNEY CHANG

22 *Hot Bed*
 Cibachrome print, 16" x 20". Artist's collection.

Born: 1945, Honolulu, Hawaii
Education: 10 college degrees, including Northern Illinois University, MA, Painting; The Union Institute, Ohio, PhD, Art Psychology; Columbia Pacific University, MA, Computer Art.
Selected solo exhibitions:
1991 U of Oregon Continuation Center, Portland, OR
1990 Las Vegas Art Museum
1990 The Forum, Gutersloh, West Germany
1990 Tartu State Art Museum in USSR
1988 Shanghai Art Museum
Group exhibits:
1990 Siggraph, Dallas, TX
1989 Holter Art Museum, Montana
1986, 1988, 1990 Honolulu Academy of Arts
1987 Bronx Museum of the Arts

Represented by *Art Resource Group*, Eugene M Siegel, 1179 Kahili St, Kailua, HI 96734 808·262·1878
808·262·2152 Fax

ERICA CHAPPUIS

63 *Little Fishes*
 Acrylic on museum board with enamel paint, 7" x 9".

Erica Chappuis' work in painting and printmaking reflects a love of the sensual, natural energies inherent in all human beings. Just as the lotus, which has its roots in the rich, primordial muck of the lake, blossoms into the beautiful, thousand petalled flower which opens to the sun, so nature intends the spiritual flowering in us, our lives firmly rooted in this rich opulence which is our natural, earthly selves. Chappuis is primarily influenced by the art of India, the Near East and world mythology. She exhibits regularly, has received numerous awards, and is represented in private collections throughout the US and Europe. She is listed in *American Artists* (1991), *Erotic Art by Living Artists* (1991), the *Artists' Way* (1987), and Video Detroit on PBS 1983.

1251 Beaconsfield, Grosse Pointe Park, MI 48230
313·822·3647
Represented by *Detroit Artist's Market*, 1452 Randolph St, Detroit, MI 48226 313·962·0337
Hamlet Gallery, 1412 N Wells St, Chicago, IL 60610
312·642·4444

PETER CHRISLER

59 *Garden Facade of Palace*
 Ceramic with porcelain finish, 12½" x 15".

Peter Chrisler works in various mediums within certain decorative styles to achieve an effect that emulates the past. He utilizes existing styles but extends the boundaries of those styles

and so is original while still being historically correct. "My works respond to a personal need, recapturing a longing for a vanished world that seemed to me as a child far more real than my contemporary surroundings."

1745 Franklin St #204, San Francisco, CA 94109
415·673·7754

JAN COOPER

41 *Camelot*
 Acrylic, 22" x 28".

Jan Cooper's paintings are represented in private collections from coast to coast. "I specialize in painting scenes where people have spent memorable and happy times together." In 1972 he won the AAA Automobile Association Award for Superior Art Instruction. In 1988 he hosted a TV show interviewing artists. He is author of *The Artists Survival Guide* and The *Artists Renaissance Course*. In 1991 he plans to inaugurate an annual auction in Sacramento, CA, for living artists nationwide entitled "Artists on the Rise." He received the George Washington Honor Medal from the Freedom Foundation at Valley Forge in 1988.

Box 18, North Highlands, CA 95660 916·726·0911

NILES CRUZ

26 *Night Sparks*
 Acrylic on canvas, 48" x 64". Artist's collection.

26 *The Ordinary Life*
 Acrylic on canvas, 48" x 64". Artist's collection.

Solo exhibitions:
1980 Lotus Gallery, NYC
1979 Bank of Interamerican Development, Washington, DC
1977 Museum of Contemporary Hispanic Art, NYC
Selected group exhibitions:
1991 "72nd National", George W Smith Museum,
 Springfield, MA
1991 "Hudson Open '91", Hudson River Museum, NY
1989 "Mixed Media," EB International Gallery, NYC
1981 "Brooklyn '81," Brooklyn Museum, NYC
1980 "35 Under 35," Lever House Gallery, NYC
1979 "Brooklyn '79," Brooklyn Museum, NYC
1978 "Magnet," Bank of Interamerican Development,
 Washington, DC
1978 Maracaibo Museum of Graphic Arts, Venezuela
1977 "Confrontacion: Ambient Y Espacio," Museo Del
 Barrio, NYC
1977 Association of Hispanic Arts, NYC
Exhibited by invitation in 1981 at IV Biennial De Arte Medallin, Colombia. In the collections of: Museum of Contemporary Hispanic Arts, NYC; Museo Del Barrio, NYC; and Maracaibo Museum of Graphic Arts, Venezuela.

14 Jackson Pl, Brooklyn, NY 11215 718·499·1457

IVO DAVID

54 *The Filthy Harpies, Dante's Inferno XIII*
 Oil on canvas, 22" x 30". Artist's collection.

"In the art of Ivo David, paradox and parody are amalgamated in the fusion of two ethereal and sublime forms that show the oneiric unconscious where the psychic meets with the physiologic, the surreal predominates over the social and biological, the modern is next to the classical, the profane next to the sacred. Nevertheless, his metaphysical world (especially in the illustrations of Divine Comedy) always contains a moderate and controlled surrealism that unites faith and reason. The fusionistic art movement founded by Ivo David (1956) is expressed in his "Manifesto of the Fusionism".

 Fatima Catherine Wall

2027 High St, Union, NJ 07083 908·964·5660

MABEL MARTIN DAVIDSON

68 *My Judy*
 Acrylic, 14" x 11". Private collection.

"Progressing from simple oil landscapes to detailed acrylic paintings, my goal has been to portray on canvas the subject as it appears in real life. This pose of my daughter was captured as she watched wildlife in its natural environment. The tranquil setting nestled in the hills of Kentucky seemed to be the perfect spot for enjoying the beauties of nature. By knowing the Creator as Lord and Saviour, we experience a peace within that only comes from God."
I will lift up mine eyes unto the hills, from whence cometh my help. My help cometh from the Lord, which made heaven and earth. Psalms 121: 1 and 2

Rt 2 Box 431, Mt Vernon, KY 40456 606·965·3123

PETER DEROZZA

48 *Madonna and Child*
 Charcoal, 50¼" x 77⅞". Artist's collection.

Education: CSU, Long Beach, CA, MFA 1977
 Otis/Parsons Art Institute, LA, CA, BFA, 1973-4
Peter DeRozza's work reflects a personal interpretation of power as it is distributed amongst men (mankind) by men (males), particularly in America. He works in many media, including drawing, painting and sculpture. He also believes that an artist's work should show his/her personal work and not the best efforts of a team of factory technicians and engineers. He prefers to work with materials that can be bought locally.

540 Blaisdell Dr, Claremont, CA 91711 714·624·2271

BIRDELL ELIASON

69 *Early American Classroom*
Oil on masonite, 16" x 20".

69 *Grandma's Daisies*
Oil on canvas, 16" x 20".

Oregon-born artist Birdell Eliason carries a sketchbook wherever she goes, to capture ideas and colors for future paintings. Historical styles, native people, interesting buildings and colorful flowers are some of her favorite subjects. By putting old-fashioned clothes on present-day people, her creative imagination composes a picture of the past. Her awards include the Statue of Victory World Cultural Award, the Golden Palm of Europe, the Premio Milano and numerous others. Her most recent award was first place in the new history book contest for the Mt. Prospect Historical Society and Windsor Publications. She also created the watercolor pictures for participants in the Mt. Prospect Historical Society's Annual Christmas Housewalk. Eliason is listed in several publications, including *Academia Italia delle Arti del Lavoro, Chicago Art Review, American Artists* and *Artist U.S.A.*

12 N Owen St, Mt Prospect, IL 60056 708·259·6166

W T ELKINS

27 *Old Friends*
Oil, 20" x 24". Artist's collection.

"Words are hard for me, so I speak through my paintings. If you wish to understand what I am saying, you must look with an open heart and an open mind."

PO Box 4447, Anaheim, CA 92803 714·635·1995

DEMPSEY ESSICK

39 *Springtime at Irena's*
Watercolor, 22" x 26".

Dempsey Essick seeks to realistically capture everyday subjects in their natural setting. Hours of concentrated painting time capture the intricate detail of chosen subjects. "I like to feel that I can literally touch what I have painted." From his architectural and mechanical drawing background, Dempsey acquired an understanding of perspective and design. He favors subjects with historical content. His paintings evoke a nostalgia for the quiet country places and friendly country people that he loves, and possess a sense of calm that can be felt by the onlooker. His works have been published as posters and greeting cards and have been featured in several prestigious publications.

Rt 18 Box 2518, Lexington, NC 27292 704·249·9857
Represented by *First Avenue Gallery*, 18 W First Ave, Lexington, NC 27292 704·249·7046

BRIAN FLYNN

19 *44 Margarets*
Mixed media on board, 24" x 36".

"Inspiration comes in the moment. It's either there or it's not. Works like *44 Margarets* are spontaneous, born of love and joy and satisfying a need in the moment. When I work, I work passionately, using the largest brushes I can to help me achieve my goal. The rest is mystical. The alchemical transformation of base matter (in this case, color pigments, binder, glue, paper) into a comprehensible visual language. It is secretly a divine process."

PO Box 500, Oregon House, CA 95962-0500 916·692·1356
916·692·1370 Fax

PERLA FOX

15 *Roses*
Watercolor, 21" x 28½".

Born in Washington, DC, Perla Fox first exhibited watercolors there in 1962. Since 1972 Fox has lived and exhibited in Israel. Most recent exhibits: ART Expo NY and LA, 1990 and 1991; ISART, Tel Aviv, Israel, 1991.
Publications: Featured in Israeli magazine *World of Art*, 9/79
Books: *ISART - Israel Painters & Sculptors*, Israel, 1981, 1991; *Encyclopedia of Living Artists*, 1988, 1989, 1990, 1991
Limited editions: Serigraphs and lithographs by Jacques Soussana-Graphics, Jerusalem, Israel.

4860 Van Noord Ave #4, Sherman Oaks, CA 91423
818·990·7762
PO Box 834, Kfar Shmaryahu 46910 Israel 972·52·583·590
972· 52·583·237 Fax
Represented by *AJW Fine Art Inc*, Shirley Myers, 5225 Pooks Hill Rd, Bethesda, MD 20814 301·530·5832
301·530·2486 Fax
Carol Schwartz Gallery, Chestnut Hill Ave at Bethlehem Pike, Philadelphia, PA 19118 215·242·4510
Jacques Soussana-Graphics and Gallery, 37 Pierre Koenig St, Talpiot, PO Box 4219, Jerusalem 91041 Israel
972·2·782·678 972·2·782·426 Fax

LUDMILA GAYVORONSKY

58 *It Is Over*
Oil on canvas, 20" x 24".

Ludmila Gayvoronsky applies passion with paint in such a forthright manner that her expressions of the enigmatic drama and turmoils of human and political conditions are utterly genuine and visceral
"Her technically proficient draftsmanship and her distinctively individual imagination stand outside any regional classification and establish her as a member of the international art world."
Dennis Wepman, Manhattan Arts, November 1989

1690 Union St #2C, Brooklyn, NY 11213 718·756·3453

PATRICIA GEORGE

60 *Arch Shadows*
 Oil on canvas with knife, 30" x 40".

61 *Santorini Shadows*
 Oil on canvas with knife, 20" x 24".
 Private collection.

Patricia George is a Southern California artist who travels extensively around the world in search of new subject matter for her paintings. She was one of 14 artists from 10 countries invited to exhibit in Athens in September, 1990. She also exhibited twice in Paris last year. The first show was at the "Salon De Vieux Colombier" in October 1990 and the second at the "Chapelle de la Sorbonne" in November 1990. Her most recent award was the "Laureat 90" given by the Mayor of Paris in conjunction with her Parisian show. Last year she received the "Prize of Honour" from the Paul Dumail Museum in Bordeaux, France. She will exhibit in France again this year. George has been profiled in *Metro* magazine, the *California Art Review* and *American Artists, An Illustrated Survey of Leading Contemporaries*. She was recently accepted into the second edition of the *California Art Review*. She was featured in both the January 1990 and the January 1991 issues of the New York magazine *Manhattan Arts* as one of the "Artists of the 1990's." Her artwork has been published in the third, fourth and fifth editions of the *Encyclopedia of Living Artists in America*. Her works hang in the corporate collections of INSTAR and JC Penny's, as well as in many private collections.

Suite 221, 4141 Ball Rd, Cypress, CA 90630 714·826·7945

PAUL HARTAL

14 *Horsehead Nebula*
 Oil on canvas, 22" x 28".

Exhibitions: Luxembourg Museum, Paris; Sion Museum, Switzerland; Munson-Williams-Proctor Institute, NY; Alcorcon, Madrid; Colbert, Montreal.
Collections: Guggenheim Museum, NY; National Gallery, Ottawa, as well as many private collections world-wide.
Awards: Prix de Paris; Rubens; Selected Olympic Artist, Seoul, 1988.
Paul Hartal is the originator of "Lyrical Conceptualism." He directs the Centre for Art, Science and Technology in Montreal. He is listed in *Who's Who in Art, Dictionary of International Biography, Encyclopedia of Livings Artists, Fifth Edition* and others.

PO Box 1012, St Laurent Centre for Art, Science and Technology, Montreal, Quebec Canada H4L 4W3 514·747·4571

ALVIN C HOLLINGSWORTH

30 *City in Gold and Black (Lincoln Center Series)*
 Oil and acrylic collage, 28" x 36".

31 *He Lives (Visionary Series)*
 Oil and acrylic, 46" x 56".

Alvin C Hollingsworth is a native New Yorker and full Professor at CUNY. He devotes his non-teaching time to painting. He is noted by Jeanne Siegal in *Artwords* as one of the leading painters in the country. Professor Hollingsworth's works are in the collections of IBM, Chase and the Brooklyn Museum.

614 W 147th St, NY NY 10031
Represented by *Allan Stone Gallery*, 48 E 86th St, NY NY

DAVID LEON HOLT

42 *Figures within the Plane*
 Soft pastel/charcoal, 14" x 17".

David Holt has been dedicated to art since the age of four, when he won his first competition. He has studied in many California art workshops and schools. He has also had shows throughout California. He aims to expand people's awareness through the prophetic and creative forces in art. "Art is blood and life to the artist, the only way he can express his feelings to the fullest."

1245A Rodriguez St, Santa Cruz, CA 95062 408·475·1816
Represented by *Ariel Gallery*, 470 Broome St, NY NY 10013

WINSTON HOUGH

64 *Matisse Park*
 Acrylic, 47" x 33½".

His favorite points of view on twentieth-century art: it is an art of contemplation (Matisse, Bonnard, Tobey); humanist or social figurative (Gwathmey, Hartley, Evergood, Picasso); and, an art of magical abstraction (Miró, Arp, Klee). In "Matisse Park" he started with a turgid city that was destroyed with a peaceful park. He has exhibited in NY, DC, NC, IN, WI. Received the Huntington Hartford Foundation Fellowship.
Solo shows:
1990 Art Reach Gallery, Columbus, OH
1988 Beverly Arts Center
1987 Concordia College, Riverforest, IL
1984 Gruen Gallery, Chicago.

937 Echo Lane, Glenview, IL 60025 708·729·0915

WILLIAM HOWE

38 *Mexican Mosaic*
 Acrylic on canvas, 24" x 30". Private collection.

Butterflies depicted in varying formats are the exclusive subject of William Howe. Though the basic patterns of the actual butterfly species are faithfully portrayed, Howe adapts the butterfly wings to both surreal and abstract concepts. In either style, attention to details of the butterfly selected is meticulously maintained. Migration scenes (such as *Mexican Mosaic*) depict actual migrations of butterflies that the artist has personally witnessed in Mexico and Guatemala on butterfly-collecting trips. He has visited the jungles of Mexico and Central America in pursuit of butterfly specimens 58 times. He lives the paintings

he executes and each original is based on an intimate, first-hand knowledge of the butterflies he collects and observes in the field.

Public collections: Smithsonian Institution, Washington, DC; American Museum of Natural History, NYC; Carnegie Museum, Pittsburgh; Illinois State Museum, Springfield, IL; San Diego Museum, Balboa Park; Museum of New Mexico, Santa Fe; Los Angeles County Museum, Exposition Park; Denver Museum of Natural History; Milwaukee Public Museum; and others.

822 E Eleventh St, Ottawa, KS 66067 913·242·4148
Represented by *Ariel Gallery*, 470 Broome St, NY, NY 10013
Chris' Corner, 229 S Main St., Ottawa, KS 66067

WILLIAM SHIH-CHIEH HUNG

20 *Red Apron*
 Oil on canvas, 38" x 30".

21 *Chinese Lady*
 (A Portrait of My Wife Susie Hsueh-Ping)
 Oil on canvas, 36" x 30".

PO Box 20133, El Sobrante, CA 94820

R RANDALL IACCARINO

49 *La Mantra de Itabo (The Blanket of Itabo)*
 Watercolor, 48" x 48". Private collection.

R Randall Iaccarino's monumental-size watercolors have a palpable sense of the magical, a strong intuition that there is more than what we see. They have no visual limitations or boundaries but relay creation's ever-changing appearance and ultimate mystery. Many of these watercolors are inspired from yearly painting tours to the jungles and rain forests of Costa Rica where "The Emerald", a rain forest retreat, becomes Iaccarino's studio and source of inspiration. "My watercolors in their execution and subject matter pertain to the gentle, creative aspects of mankind and our surroundings. They are intended to elevate the human condition on physical, emotional, psychological and spiritual levels." *The Blanket of Itabo* incorporates traditional Central American native design and abstracted interpretations of jungle flora. These paintings address the interrelatedness of humankind and the natural world. Limited editions and multiples are available.

115 McClellan Blvd, Davenport, IA 52803 319·359·5522

STEPHEN JOHNSON

35 *The We Love You Painting: Jesus, Giner and Mozart*
 Acrylic on canvas, 36" x 36". Artist's collection.

Exhibits:
1991 Sister Kenney Institute, Minneapolis, MN
1989 Center for Creative Arts Therapy, Denver
1989 Naropa Institute

1989 Aspen Art Museum, CO
1989 Pueblo Arts Center, CO
1989 Boulder Artists Gallery, CO

Johnson attributes his paintings to three different personalities within him. He calls one Stephen, one Ginger, who represents his feminine side, and one Robin, a man he says he doesn't know very well. His work has served as a powerful healing vehicle for himself.

PO Box 2004, Boulder, CO 80306
Represented by *Scott Johnson*, 5280 Auburn Rd NE, Salem, OR 97301 503·581·3397

RON JONES

56 *Billy*
 Platinum-Palladium, 18" x 12". Artist's collection.

56 *Gullfriend*
 Platinum-Palladium, 18" x 12". Artist's collection.

56 *Maine Fog*
 Platinum-Palladium, 17" x 14". Artist's collection.

Producing award-winning advertising art design and photography for more than 30 years, Ron Jones has passed his entire working life immersed in the arts. The last five years were spent developing and perfecting large-sized alternative printing of photographic images, especially Platinum and Palladium. Palladium print production presents many complicated facets, but the achievement of a well-printed image is worth the effort. These prints are unique and possess a depth and romance impossible to capture in other forms, not to mention reproductions. After years of working on this process, a level of quality has been achieved and is ready for a collector's consideration. Portfolio available.

2406 Birch Dr, Silver Spring, MD 301·587·2210 301·588·2708

JOHNNIE JORDAN

44 *After Hunting Season*
 Pen and ink on illustration board, 28¾" x 18¾".
 Artist's collection.

Johnnie Jordan is one of the world's foremost pen and ink artists. It is extremely rare to encounter ink drawings as large as those he executes. The image area of his largest drawing is 22" x 32". Jordan also paints in watercolor and oil, but his expressions with pen and ink demand attention and respect. "I like pen and ink because it gives me great depth and perspective." A very unusual aspect of his work is the extensive use of people and animal subjects in the same composition, which creates a great demand for intricate details. His drawings of people often show positive race relations. Jordan began his experiments with the pen in 1958, and has since developed his own unique style. His work has been presented to three presidents and to the LBJ Library. His name is rapidly becoming known through an extensive national art program.

6400 N 11th St, Philadelphia, PA 19126-3730 215·424·0331
215·224·6895 Fax

MARIA DELIA BERNATE KANTER

28 *The Condor of the Andes*
 Acrylic on canvas, 48" x 36".

Maria Delia Bernate Kanter has had many exhibits in the United States, Japan, France, Spain, Colombia and Mexico. Last year in France she received the first prize "La Plaque D'Or -- Grand Prix d'Aquitaine" for her work *Save the Amazonia!*. It was also included in L'Exposition Internationale D'Arts Plastiques at the Chapelle de la Sorbonne in Paris and at the Musée de la Commanderie D'Unet in Bordeaux, France. Says Jane Chiroussot-Chambeaux, noted French art critic, "She paints the jungle of her native Colombia, ever changing, full of color, vibrant and in danger of destruction. The intensity of her work reflects her boundless emotion, imagination and intelligence used during the creation of her art. A memory of a jungle loved dearly and described here vividly. The painting reveals the artist's anguish over the jungle's imminent destruction by mankind. The painting cries out for the defense of the Amazon, *Save the Amazonia!"*

6155 La Gorce Dr, Maimi Beach, FL 33140 305·865·9406
Represented by *Artcetera*, Gloria Waldman, 3200 S Congress Ave #201, Boynton Beach, FL 33426 407·737·6953

RICHARD KARWOSKI

24 *Mixed Fruit on Blue*
 Watercolor, 22" x 30".

24 *Nasturtiums in Monterey*
 Watercolor, 22" x 30".

Since 1983 Richard Karwoski has incorporated various compositional concepts into his paintings. Although still life and landscape elements were characteristic of his work over the last decade, they now play a subordinate role. In recent years he has introduced geometric elements and areas of gray and brown where color would ordinarily be. By integrating color into the total visual statement, and dividing surface space with linear and angular shapes at various optical distances, he is creating images with an illusionary impact.

28 E 4th St, NY NY 10003 212·254·1618

ROBERT F KAUFFMANN

34 *Division of Plane with Dragon*
 Serigraph, 18" x 24".

Robert F Kauffmann was born in Willingboro, NJ , in 1963, and currently resides in Cinnaminson, NJ. Kauffmann received a BA in Computer Science from Rutgers University in 1987. He has illustrated a children's book entitled *Robert's Rhymes* by Robert Morse (1988) and his artwork has recently been reviewed and published in *American Artists Illustrated* (1991). Kauffmann's graphic art often illustrates a visual conundrum and mathematical paradox, from which the work derives its

balance, complexity and theme. Current media include printmaking (serigraph and linocut), and drawing (pencil, pen and ink, brush marker).

2401 Arden Rd, Cinnaminson, NJ 08077 609·829·7725

WILLIAM KENDRICK

43 *Marakech*
 Watercolor, 22" x 30".
William Kendrick has lived and worked among the peoples of the Middle East. He was born in 1928 in Charlotte, NC, and moved to Virginia as a child. He graduated with a BFA from Virginia Commonwealth University and received a scholarship to study under Harriet Fitzgerald at the Abingdon Square Painters Studio in New York. In September 1991 Kendrick will be having a show at the National Press Club in Washignton DC. He has won numerous awards and honors.
"Owning a Kendrick painting is like owning an extra window. He is a true servant of light, reminding us that the real world - as accessible as a bunch of field flowers in a jug - is a quietly glorious place to live. True art always reminds us of this and Kendrick, who works with the perfection of a stained-glass maker, irradiates his materials and the beholder. We are better for what he sees."

 Phyllis Theroux, New York Times

1410 Cole Blvd, Glen Allen, VA 23064 804·266·6269

NANCY KIDD

32 *Grandpa's Bike*
 Acrylic, 35" x 41".

Education: El Camino College, Torrance, CA, AA with honors.
Selected exhibits:
1987 Apple Computer, Cupertino, CA
1988 Hewlett Packard, Cupertino, CA
1989 Fine Arts Institute of the San Bernardino County
 Museum, CA
1991 Xerox Credit Union, Sunnyvale, CA
"It is of primary importance in my work to capture the effects of light and shadow, whether it be in a landscape or a figurative painting. I traditionally paint "upclose" and detailed. My objective is to give an intimate view our our world.'

930 Rockefeller Dr #16A, Sunnyvale, CA 94087 408·773·0971

ISAO KURIHARA

14 *Embroidery Kimono and Doll*
 Oil on canvas, 26" x 21". Artist's collection.

Isao Kurihara studied at LTS Art Academy in Japan for nine years. He has attended a Master workshop at Long Island University in the US. He has had solo shows in Japan and Manhattan. Awards: Dutch Canadian International Exhibition, 1st Prize; Certificate of Excellence, Art Horizon's New York International Art Competition. Displayed in Tokyo Metropolitan

Art Museum nine times. Received many awards in Japanese exhibitions.
Painting style: realism and cubism, sometimes Yuanan style.
3047-13 Fuchigashira-cho, Mitsukaido-City, Ibaraki, Japan 303

ATHENA LACIOS

42 Greek Landscape
 Oil, 20" x 23".

Athena Lacios is both painter and sculptor. She has had shows in Paris at the Duncan Gallery, New York at Salmagundi Club and Kolter Gallery, in Florida at the Artists League, and in New Jersey and Washington DC. She has received the Palm d'Or (Golden Palm) in Paris.

103 Roberts Rd, Englewood Cliffs, NJ 07632 201·568·3355
Represented by *Paulette Anagnostaras,* 345 E 81st St #9K, NY NY 10028 212·535·4181

SILJA LAHTINEN-TALIKKA

29 *Atlanta Spring*
 Oil on canvas, 22" x 36".

29 *Tornado Season*
 Acrylic on canvas, 72" x 130".

Born in Finland, Silja Lahtinen-Talikka attended Helsinki University where she received a BA and MA. She also attended Taideteoll Oppilaitos, Helsinki; Atlanta College of Art, GA, and Maryland Institute, College of Art, MD.
"All I ever wanted was to do the best painting and become the best. I am looking forward to the time of 2000. My instrument is myself and my style is what I am. I am all alone." Every painting is an external map of Lahtinen-Talikka's most secret interior. "After every work I must forget what I did and dare to ask again, Now what? Every generation before us was able to keep this earth clean and leave great monuments of their cultures. Art seems to be like a tree. As soon as it has been labeled and established, it changes form and appearance."

5220 Sunset Tr, Marietta, GA 30068 404·992·8380
Represented by *Ward-Nasse Gallery,* 178 Prince st, NY NY 10012; *Avery Gallery,* Marietta, GA; *Gregg Art Gallery,* La Puente, CA; *Gallery Taide-Art,* Helsinki, Finland

MARY LOGAN

67 *Mike*
 Pastel, 18" x 24". Private collection.

Mary Logan is primarily a self-taught artist. She has been drawing and painting since the age of three. Although she is well known for her wildlife illustrations, she has always been intrigued with the human face and figure and works well in all areas and media. She especially concentrates on pen and ink,

pastel, and watercolor and often mixes her media. Her work has been exhibited in northwest Washington and is collected internationally in private homes as well as in hospitals and other institutions. She is included in the second edition of *American Artists' Survey,* as well as in the fifth edition of the *Encyclopedia of Living Artists in America.*

PO Box 4364, Bellingham, WA 98227 206·671·2253
Represented by *Ariel Gallery,* NY NY

HOPE MARIE MAKI

55 *Mother and Child Mermaid*
 Oil, 22" x 28". Artist's collection.

Hope Marie Maki has many styles and is one of today's most versatile and internationally acclaimed artists. Maki works in all media and subject matters and has been commissioned by his eminence Prince John of Tasmania, Australia, to create a 4' x 8' oil to be permanently exhibited in Ormiston Palace. She has received recognition from many celebrities, and her biography appears in over 30 reference books from the US to India. In 1989-1990 Maki became a noble by a grant of Arms for Heraldry as a salute to her art achievements. Her biography and art will appear in the fourth edition of the *New York Art Review,* *American Artist Reference* (second Edition) and *Illustrated Survey of the Leading Contemporaries in America.* She was chosen as Woman of the Year (1990) by the American Bio-graphical Institute.
In 1963, Hope Marie Maki created art for the blind that opened new doors for them. She felt the blind should be able to experience her art as well as the sighted. She also created a new type of art called "wacky art." She likes inventing art for her viewers. Original paintings and signed, limited edition prints are available at the Estate Gallery, noted below.

3985 Langley Ave, Pensacola, FL 32504 904·478·4673
Represented by *Estate Gallery and Museum Inc,* Mr Phil Banks, 401 E. Chase St, Pensacola, FL 32501 904·469·9050

GUIYERMO MCDONALD

50 *Tribute to Picasso*
 Oil on masonite, 24" x 48". Artist's collection.

50 *Flight into Egypt*
 Oil on canvas, 37" x 53". Artist's collection.

51 *The Seven Colored Horse*
 Oil on canvas, 37" x 53". Artist's collection.

Guiyermo McDonald is an artist of strong personality whose paintings reflect a combination of classical and contemporary art. His art has received a great deal of public attention. He was born and educated in Peru. During his eight years as a student in Lima, he received first prize each year in drawing, oil painting, mural painting, watercolor and engraving. He also has won three scholarships in England, France and the United States.

60 Matisse Rd, Route 5, Box 5464, Albuquerque, NM 87123
505·293·2276

GRACE MERJANIAN

40 *Promise of Spring*
 Watercolor with gouache, 21" x 30".
 Artist's collection.

Shortly after she started painting 17 years ago, Grace Merjanian was painting a rose in her backyard when a butterfly flew to her canvas and sat on the painted rose thinking it was real. That excited her so much that she has been painting ever since. Merjanian's realistic style has won her numerous awards. Her paintings are in collections throughout the United States, France, Canada, Lebanon, Germany, South Africa, South America and England. She teaches art and is active in the art community, presently serving as president of the Costa Mesa Art League. She is an associate member of the National Watercolor Society and Art A-Fair Festival in Laguna Beach, CA, and a charter member of the National Museum of the Arts, Washington, DC. Reproductions available.

18701 Deodar St, Fountain Valley, CA 92708 714·968·5983
Represented by *Bill W Dodge Galleries*, Carmel-by-the-Sea, CA, and Cannon Beach, OR
Graphics Gallery, Mission Viejo, CA

EUSTACHY MICHAJLOW

52 *Haziness*
 Oil, 16" x 20".

52 *Steppecossock*
 Oil, 18" x 24".

Born in Poland of Russian descent, Eustachy Michajlow began drawing animals and people at the age of nine. After the war he studied for two years in Germany with Polish artist F. Teogel. In 1951 he emigrated to the United States and met Russian artist S. Selvanowski, with whom he studied for six years. He also associated with Professor J. Glotzer, graduate of the Royal Academy of Fine Art in Vienna. Michajlow's paintings are exhibited and displayed in many galleries, and have won ribbons and cash awards. Today he paints vivid scenes of the beautiful Old World in Flemish style. "What I paint comes from my soul."

Represented by *Hacienda Del Rio Gallery*, 341 Rio Grande Dr, Edgewater, FL 32141 904·423·4683

EDUARDO NERY

 Spray painting on golden wood panel, 36" x 48".

Eduardo Nery was born in 1938 in Portugal. He received a degree in painting from the Fine Arts Academy of Lisbon. He worked in tapestry art under painter Jean Lurcat in France from 1960-61. Nery's main fields of work include painting, drawing, engraving, tapestry, ceramics, stained glass and photography. He has had 48 solo exhibits in Portugal and abroad. He has had 150 other exhibits in Portugal and 50 abroad. He is represented in 14 art museums and has won many prizes and awards in various countries.

Av Columbano Bordalo Pinheiro, 95 - 7º, Dto, 1000 Lisboa, Portugal 726·16·68

JOHN OSHYPKO

57 *Paean to Coke*
 Alkyd on canvas, 36" x 36".

57 *Kite Over Dune Point*
 Acrylic on canvas, 48" x 36".

Exhibits:
1991 Gallery North, "Local Color III"
1990 Brentwood Library
1989 Islip Art Museum
Education: BFA, Tyler School of Fine Arts (Temple U)
In collections of Nelson G Harris, Tasty Baking Co and EK Vanderbilt.
John Oshypko's paintings are representational and sometimes allegorical, with an occasional surreal touch. His subject matter is landscapes and cityscapes.
"Artist with a flair for drama - keen draftsmanship".
 Manhattan Arts Magazine, 1990

13 Fifth Ave, PO Box 311, Brentwood, NY 11717-0311
516·273·6023

HAROLD PARKHILL

45 *Our Heritage*
 Oil, 28" x 30". Artist's collection.

Harold Parkhill's art covers a wide range of subject matter, some of which reaches back through the centuries, as well as present day subjects. An oil and watercolor painter of landscapes, figures, animals and still-life; his work has won many awards over a period spanning nearly thirty years. Recent award: First place painting, International Platform Association 26th Annual Art Show, Washington, DC, 1990.
He is included in the ninth and tenth editions of Marquis *Who's Who in the World*, fourth and fifth editions of the *Encyclopedia of Living Artists in America*, second edition of *American Artists, An Illustrated Survey of Leading Contemporaries* and many others.
Parkhill is currently showing in *Modern Maturity* magazine's "Seasoned Eye 3", a national traveling exhibition which closes at the Kennedy Center, November 30, 1991.

PO Box 85, Coshocton, OH 43812 614·623·8852

ALAN PLAVEC

58 *Kinetic Form*
 Watercolor, 36" x 28". Artist's collection.

To explore watercolor imagery; not imitating, but reflecting. Alan Plavec's approach is fresh, painterly and spontaneous,

looking for impact on a variety of levels. His imagery evolves through intuition, rather than literal interpretation. Being primarily affected by natural images, Plavec uses landscapes as an inspiration. More cerebral than visual, the literal meaning is no longer necessary. Atmosphere and light interest him and how they are affected by the image. "On impulse, I poetically reinterpret an image, creating drama and mood from within."

608 Krenz Ave, Cary, IL 60013 708·639·2889

GILDA PORCORO

42 *The Barn*
 Oil.

Gilda Porcoro has studied with various instructors; still life and portraits with Helen Van Wyke, landscapes with Arthur Maynard, flowers with Rosemary Cox, seascapes with Charles Henry Norman, anatomy and composition with Tom Costanza and Susan Liss. She has won several awards including the Gran Prix Humanitaire de France in 1976. Porcoro's works can be found in foreign collections as well as collections in the United States.

5-18 Canger Pl, Fairlawn, NJ 07410 212·535·4181
Represented by *Paulette Anagostoros*, 345 E 81st St #90, NY NY 10028 212·535·4181

MICHAEL RASMUSSEN

48 *The Archer*
 Casein on canvas, 11" x 14". Artist's collection.

Michael Rasmussen graduated in 1978 with a BFA from Colorado University in Boulder, Colorado. He is seeking to broaden a customer base for his current works. A brochure of his current work is available.

1122 Portland Pl #208, Boulder, CO 80304 303·449·7924

ROYCE MARIN REIN

62 *The Red Room*
 Acrylic on canvas, 36" x 24". Artist's collection.

Most of Royce Marin Rein's paintings are acrylic or gouache. Some are figurative, while others tend toward abstraction. Color is the most important element, whether flat, modeled or patterned. He is a 1964 graduate of the Minneapolis College of Art and Design. His most recent show was in February 1991 at the CODA Design, Minneapolis, MN.

2548 Clinton Ave S, Minneapolis, MN 55404 612·874·9377

ELLING REITAN

9 *The Sun is Breaking Through*
 Oil, 31" x 25". Private collection.

Solo shows in New York City:
Noho Gallery, December 1991
Morin-Miller Galleries, 1989
Ariel Gallery, 1988
Group show at Windsors Gallery, Miami.
Studied with Norwegian master Odd Nerdrum.
"Elling Reitan has good command of his dramatic compositions and explores them with his own personal sense of color harmony. His skill in draftsmanship is very evident, especially in the fine expression of his nudes." ARTspeak, NY November 1989

Viktor Baumanns V 19B, 7020 Trondheim, Norway
47·07·516·538 47·07·978·416 Fax
US mailing address: PO Box 369, Renaissance, CA 95962

ROLLA RICH

66 *Columbus Day*
 Tempera and acrylic, 22" x 30".

Rolla Rich began his art career as a third grader doing pictures of famous Revolutionary War to WWII battles. He got his first actual commission when only ten, doing western and wildlife paintings for collectors in Montana and California. While in high school, he was commissioned to do some large paintings of US Navy carriers and their tall ship counterparts as part of a 50th anniversary of naval aviation. After high school, Rich worked for a year in Washington, DC doing design and drafting for the Polaris submarine project. In college, he began winning prizes at various art shows in various media, pencil, painting, cartooning and decorative art. He later became a guest instructor in art at Central Washington University, where he had attended. He was a medical physicist in the Army for eleven years doing his own art for journal and magazine articles. He is now president of Western Artists of America.

PO Box 7, Imperial, CA 92251 619·352·2319
Represented by *Diana Gillis*, New Mexico 505·524·8156
Muriel Rich, California 619·353·0686

DOROTHY ROATZ MYERS

62 *Found Safe*
 Oil, 16" x 24".

Dorothy Roatz Myers exhibits internationally and has work in many collections. She belongs to the Salmagundi Club, Art Students League, New York Artists Equity, Arts, Sciences Lettres in France, and The Hellenic Arts Institute in Greece. She appears frequently on radio and TV, and is available to lecture, critique art and judge exhibitions.

Box 204, FDR Station, NY NY 10150-0204 212·838·0932
Represented by *Morin-Miller*, Pennsylvania; *Galerie Letetia*, Marseilles; *Phoebus Touring Artists*, Athens; *Mondial Art* throughout Europe; *Montserrat Gallery*, NYC.

DEMETRIO ROSA

53 *The Firebird*
 Oil, 22" x 28". Artist's collection.

Demetrio Rosa was born in Italy. He obtained his art degree at the Academia of Fine Art in San Remo. He began drawing at the age of five, learning oil painting in elementary school. He started his painting career at the age of sixteen. Most of Rosa's paintings are impressionism, though he is also considered a modern expressionist and portraitist. He likes people to see and grasp the floating message of the painting and conclude by themselves the meaning. His paintings are in private collections throughout France, Italy, Philippines and the United States. Presently he is showing at Ariel Gallery in New York.

87-G Howard Dr, Bergenfield, NJ 07621 201·385·7055
201·831·1720
Represented by *Ariel Gallery*, 470 Broome St, NY NY 10013
212·966·3097

MICHAEL PETER ROSS

25 *Kiteman 709*
 Photography, 24" x 36". Artist's collection.

Michael Peter Ross uses his camera as a painter would a brush, creating multi-faceted surreal statements by merging different images into a single tapestry of time, space, matter, and life. In effect, he creates a universe where past, present and future are interwoven; a universe where life and matter form the same fabric; a universe of stark wonder where beauty reigns supreme. Ross was born in London in 1943 to an Austrian mother and a Czech father. He has a degree in aeronautical engineering and an MBA in art studies. He is currently the president of the San Diego Museum of Art Artists Guild. He now resides in San Diego, where for the past eight years he has created his latest work, entitled "Photosurrealism-2000." This work consists of over 800 different originals divided into 36 series. During its creation, Ross did not exhibit. Only in May 1990 was the work released. The response was so enthusiastic, that more than a dozen juried exhibits have displayed it since, with a major solo show in Japan.

10667 Porto Ct, San Diego, CA 92124 619·279·3289
Represented by *Masterart Studios*, 2219 W Olive Ave #208, Burbank, CA 91506
David Winsen 818·567·2698

MICAH SANGER

46 *Saddle*
 Oil on canvas, 28" x 34". Artist's collection.

46 *The Buttes - Williams Road II*
 Acrylic on canvas, 30" x 40".

47 *Mystical House II*
 Watercolor and pastel on paper, 18" x 14".

Micah Sanger, born in 1950, now lives and paints in the foothills of the Sierra Mountains. He has exhibited in Bruce Museum, Greenwich, CT, the Crocker Museum, Sacramento, and numerous galleries in California and New York. Sanger has created works that express the experience of influences of other dimensions co-existing and permeating the dimension our senses reveal to us. By interpreting the objects of this world he hopes to clarify for himself his own experiences as well as create a reminder of this broader reality for others.

PO Box 626, Oregon House, CA 95962-0626 916·692·1880
916·692·1370 Fax

MIMI SCHILLEMANS

13 *Harsha*
 Oil on panel, 42" x 50". Artist's collection.

During and after her artistic education at the Rietveld Academie in Amsterdam and at the Vrije Akademie in the Hague, Mimi Schillemans had painting lessons for many years by famous Dutch painters. Over the years her style developed from figurative to (lyric) abstract. She feels this gives her more possibilities to express her deepest emotions and reflect the sub-conscious self. Colors are important to her, therefore she mixes most of her paint directly on the painting to keep them as pure as possible. Her paintings are the result of a long process of seeking and experimenting, each time anew. Schillemans' works are represented in many private and corporate collections. She executes her paintings on commission by companies and architects.
Exhibitions in the US since 1990: Ariel Gallery, NYC (group show May 1990), Museum NECCA, Brooklyn, (solo exhibition October 1990) and Ariel Gallery, NCY (solo exhibition May and December 1991).
Works in public collections: Everson Museum of Art, Syracuse, NY and William Benton Museum, Storrs, CT.
The press on her work:
"Mimi Schillemans wields a robust palette knife of pure colors, laying in her abstract composition, then scraping the paint down to the forms' naked essence. The various turbulent color areas in "Harsha" project the artist's emotional jubilation."
 Abraham Ilein, ARTspeak, May 1991

Van Leijenberghlaan 401 (Studio: Groenhoven 419)
1082 GK Amsterdam, Netherlands
31·20·642·94·64 31·30·642·99·27 Fax
Represented by *Ariel Gallery*, 470 Broome St, NY NY 10013
212·966·3097

RUTH HICKOK SCHUBERT

32 *Christmas Anniversary*
 Watercolor (transparent), 22½" x 30".
 Private collection.

A contemporary watercolorist and teacher of the "California Style," Ruth Hickok Schubert is an art graduate of San Jose State University in California. Her freedom of expression with "singing color" is derived from the color theories of Josef

Albers and Millard Sheets. Her painting workshops in California, Hawaii, and the Northwest give form and design to the many award-winning paintings she exhibits in state and national shows. Her work can be viewed in permanent museum and corporate collections throughout the United States and overseas as well as in many private collections. She is a signature member of the Northwest Watercolor Society. Profiled in: *Art and Artist* (Bay Area), *Game and Gossip* magazine (Pacific), *Artists USA 7th Edition, California Art Review, California Works.*

2462 Senate Way, Medford, OR 97504 503·772·0136
PO Box 221804, Carmel, CA 93921
Represented by *Village Galleries*, 120 Dickenson St, Lahaina, Maui, Hawaii 96761 800·345·0585

PHILIP SHERROD

66 *Walking-signs/Adidas/Pro-Keds on Upper Broadway*
 Oil on canvas, 21¾" x 34¾".

1990 Smithsonian Institute; Hirshhorn Museum and Sculpture Garden, "New Acquisitions", DC; The Pollock/Krasner Foundation Grant
1990 Exhibit of street painters, Art Students League, NY
1988 Exhibit of Street Painters, Cork Gallery, Lincoln Center, NY; Grant from Adolphe/Esther Gottlieb Foundation; Instructor at Art Students League, NY
1987 Exhibit at Knitting Factory, NY
1986 Solo exhibit Al Ferro di Cavallo, Rome; solo exhibit Allan Stone Gallery, NY
1985 Prix de Roma, American Academy, Rome
1983 Solo exhibit at Allan Stone Gallery, NYC
1982 NEA Grant
1981 Adolphe/Esther Gottlieb Foundation Grant
1980 Creative Artists Public Service Grant

41 W 24th St, 4th Floor, NY NY 10010 212·989·3174
Represented by *Allan Stone Gallery*, 48 E 86th St, NY NY 10028 212·988·6870

YVETTE M SIKORSKY

23 *Floribunda*
 Acrylic, 36" x 48". Artist's collection.

Yvette Sikorsky's paintings bring to life both the conscious and subconscious. They have been shown in numerous exhibits in Europe and the United States. Born in Paris, Sikorsky's studies and accomplishments led to an honorable mention and a bronze Medal from the City of Paris. She has exhibited since 1985 at the Paris International Exhibit, 1986-87-88 in Westchester County, 1989-90 in solo and group shows at Ariel, Morin-Miller, Art Expo, Adora (CT). In 1991-92 she will appear in two group shows at Ariel Gallery. She is a winner in the "Competition #11" at Ariel Gallery. At the present time she is involved in commissioned work and would welcome hearing from more interested parties. Subject, technique and media are no barrier.

PO Box 146, Lake Mohegan, NY 10547 914·737·5167
Represented by *Ariel Gallery*, NY NY

ELIZABETH HOLDEN SLIPEK

33 *High Noon*
 Oil, 30" x 36".
Elizabeth Holden Slipek is a native of Blackstone, Virginia. "I should like my paintings to reflect the experience of being alive ."

3218 Seminary Ave, Richmond, VA 23227 804·355·0097

JOHNNY STEFANN

16 *Contrasto*
 Acrylic on wood, 40" x 40". Artist's collection.

16 *Movimento*
 Acrylic on wood, 40" x 40". Artist's collection.

"Johnny Stefann is an excellent painter, pledged to bridge the gap of humanity's spiritual progress through its most concise and universal marks, whose basic projects consist of taking the achromatic symbolism of celestial spheres, planetary rings, orbits and light, back to the earthly time of human labors; but with calm, with as much dignity as ambition. The series called *Contrasto* gathers dynamic shapes, orbiting 'planets' looking as if through a telescope and yet flows like coins in a slot-machine, and small constellations of colors, in fenced courses, along milky ways; in astral pictures. The boxed format dearest to this painter, once dear to dadaists and surrealists, suggests a container for a kit, where an artist's painting is a meditational exercise to be seized by the beholder. The black frame's function is to enhance the isolated chromatic intensity of the milky ways and chromatic scales, while it symbolizes the cosmic void. Thus we are in orbit..."
 Tommaso Trini, Art Critic, October, 1989

PO Box 500, Oregon House, CA 95962-0500
916·692·1356 916·692·1370 Fax
Represented in Italy by *Galleria Pace*, Piazza San Marco 1, 20121 Milano, Italy 02·659·0147 02·659·2307 Fax

JUSTIN H SUNWARD

34 *Transmutations 32*
 Oil on canvas, 41" x 41". Artist's collection.

"Justin Sunward's dynamic, diamond-shaped large canvases project a joyous sense of energy with intricate patterns of smaller inner forms and strokes that swarm over the surface in a uniquely animated manner, offering numerous optical surprises and rewards for the attentive viewer."
 Sidney Gilbert, ARTspeak, NY, February 1991
Since 1985, the artist's work has focused on the concept that a meaningful interrelatedness exists in what is commonly conceived to be Chaos or Randomness. He is recipient of many national awards. Recent exhibitions: Ariel Gallery, NYC; Gilman/Gruen, Chicago.

6054 N Hermitage, Chicago, IL 60660 312·508·5046
Represented by *Art Association of Harrisburg Sales Gallery*, 21 N Front St, Harrisburg, PA 17101 717·236·1432

RM SUSSEX

40 *St Michael's by the Sea*
 Oil, 18" x 24". Artist's collection.

RM Sussex works only in oils. Her subjects are primarily landscapes, although she also paints still-lifes, florals and figures. Greatly influenced by the French Impressionists, her colors are vivid and vibrant and her style is impressionistic. Her subjects are researched, sight sketches are made and photographs and slides are taken to facilitate studio completion. Sussex's work is found in private collections throughout the United States. Inquiries and photographs of current works are available on request from the artist.

2005 S Fairway Dr, Pocatello, ID 83201 208·237·3396

JUNE THOMAS

64 *Leopard on Beige Carpet*
 Acrylic, 9" x 12". Public collection.

June Thomas first took paint to canvas in October 1986 under the tutelage of artist Sharyne Walker. Her colors are bright and bold, her subject matter is full of jungle wildlife and teaming with tropical plants on fantasy islands. Her dreams and naivete seem to arise out of a desire from her whole spirit to create such wonderful and happy paintings.

450 Citrus Ave, Imperial Beach, CA 91932 619·423·1480

ABEL TRYBIARZ

12 *Klezmer Music*
 Acrylic resin/musical instruments,
 144" x 58" x 109".

12 *My Murdered Grandfather...And I Carry His Name*
 Acrylic resin/collage, 18" x 12" x 21".
 Artist's collection.

12 *Thoughts*
 Acrylic resin/polyester, 180" x 43" x 138".

Abel Trybiarz was born in 1949 in Argentina. He has works in seven corporations and various private collections in Argentina and Israel.
Selected exhibits:
1989 Fine Arts Museum, La Plata City
1988 AMIA Art Gallery
1987 Buenos Aires Cultural Center, San Martin Municipal
 Center
"Trybiarz is an architect, and therefore sculpture provides him with a change in the abstract formalism of his profession, allowing him to express images from an inner world in which reality and fantasy are constantly mingling. Trybiarz' work is very much connected with memory at an individual and collective level: individual because his sculptures make up pages of a personal diary; collective because they allude to mankind's past. He likes diving into his own origins and wants to reflect the passion, as well as discover what death is, what life is, what each of us is. In this search he finds concrete stories and tales that move him. He makes use of details and does not hesitate when willing to enrich the ideas with title, photographs or objects." Nelly Perazzo, National Academy of Fine Arts

Rosetti 556, Vicente Lopez, 1602 Buenos Aires, Argentina
541·760·9882 541·775·3463

LOIS VENARCHICK

22 *Argument's Reign*
 Mixed media, 12" x 14". Artist's collection.

Lois Venarchick is interested in capturing the interplay of texture, color, and light in a piece, with the natural world around her as the source of her inspiration. The layering of many media allows her to establish a growing and intimate relationship in each work, while maintaining a sense of humor and of the absurd. Having a piece demonstrate one style or technique does not concern her as much as does the interplay of all the elements. Each drawing or painting can stand alone as representative of her ability, each finished piece being the sum of all her experiences. Portfolio and resume available on request.

660 Beckett Point Rd, Port Townsend, WA 98368
206·385·3998 (evenings)